AMALGAMATED ENGINEERING UNION

ESTABLISHED 1920

SECTION 1 MEMBERS

This is to Certify that

Albert Randle

by Trade a _Turner_ was admitted a Member of

Section _1_, of the _Sandbach_ Branch,

on the _23rd_ day of _Aug_ 19 40,

at the age of _22_ years and _6_ months,

In Witness whereof we have subscribed our Names, and have affixed the Seal of our Branch.

R. Welch President.

Ramsbottom Secretary.

C.M. 20M 3/40.

Total Entrance Fee to be paid ...	£	s.	d.
Paid when proposed			
Paid when admitted		3	6
Balance due			
Balance paid			

Signed _Ramsbottom_ Secretary.

Date _23/8/40_

TABLE OF ENTRANCE FEES

	s.	d.
* Sections 1 and 2, under 30 years of age..........	3	6
* Sections 1 and 2, over 30 years of age..........	7	6
* Sections 5 (all ages from 15 to 50)...............	2	6
Section 5a ...		Nil
Section 4 ...		Nil

* These payments must be made before any contributions are accepted and include the initial cost of the Rule Book.

Sections 4 and 5a pay 6d. for copy of Rules on the night of Proposition.

UNION

Noel Bowler

KEHRER

For Úna & Maurice

INTRODUCTION BY KEN GRANT

Born in Liverpool in 1967. Since the 1980s, he has
photographed his contemporaries in the city and engaged
in sustained projects both in the UK and wider Europe.
A monograph of the Liverpool pictures, 'The Close Season',
was published by Dewi Lewis Publishing in 2002. His most
recent book, 'No Pain Whatsoever', was published by Gosta
Flemming/Journal in 2014. Ken Grant's photographs are held
in important collections of photography, including those of the
Museum of Modern Art, New York, the Folkwang Museum
Essen, the Archive of Modern Conflict, London and other
international public and private collections. He continues to
work on long term projects and currently teaches Photography
at the Belfast School of Art.

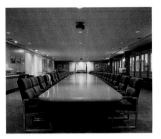

Seafarers International Union
SIU | CAMP SPRINGS — MARYLAND, USA

There are strong and complex currents in the Irish Sea. Between England, where Noel Bowler now works, and his native Ireland, there are pulls and rips that come from north and south, to wrestle at the foot of the Isle of Man. They can tip the most mature seafarers into states of contrition. Such strong and hidden flows can alter the course of lives in a moment, arriving as cold and dispassionate as sudden winter showers or as unannounced and final as a redundancy letter on a spring Friday morning. They serve as a reminder that the forces that shape our lives, whilst not always apparent or announced, are nevertheless real and all about us.

On the face of it, the ample tides that challenge navigation might seem remote from the vacant, extended table that dominates the meeting room of the Seafarers Union in Camp Springs, Maryland. Noel Bowler has photographed the room as though it were set for parliament. It is a balanced space, ready for close and equal debate. The table brings to mind the hull of a ship – or, more accurately, since chairs rise bonelike on each side of a polished wooden surface, it echoes the skeletal jig of a vessel in early construction, taking its shape… a future promised, if not yet wholly assured.

It is a quiet photograph, as many are in the series Noel Bowler has made over the last decade in the union buildings across Europe and America. Often un-peopled, they are dormant chambers, laid out ahead of debate. Whilst some rooms are novel and singular, others seem mundane, as workspaces can be; clerical spaces, where advice is taken, mediation served, and strategy shaped. If Bowler had kept closer counsel with the historical etiquette around how labour and the Union Movement has been photographed over the last century, he might have felt compelled to echo the majesty of industrial construction in process. He could have aligned himself with the press-pack, to chase the physical flashpoints of toe-to-toe disputes and their eventual bruised resolution. He might have resolved to witness deals as they were struck or stalemates as they extended… but a dust has settled on those records of labour. Economists are already heralding a third industrial revolution, a digital hybrid of manufacturing and service bases. But how will that look and where are those workers who will populate these new markets?

In truth, there has always been economic revision, and artists have rarely been slow to respond to new flows or tensions. Recent decades have proved no exception. Coco Fusco's early 1990s appreciation of the Mexican workers who manufactured parts for household computers, a presentation that concussed an academic conference on 'new media' (whatever that was) by reminding delegates of what, or who, really mattered, predated the late Stuart Hall's conversation with David Harvey, in Isaac Julien's film 'Kapital'. The film was most recently screened as part of Okwui Enwezor's 2015 Venice Biennale keynote show and included Hall's haunting question: 'How are we to understand the Class War in the 21st Century?' We are witnessing the latest consolidation of work itself and all that is affected by such changes, the inevitable shifts at the heart of family, stability, nourishment, and community. New initiatives arrive, of course, lured through incentives and promises, only to depart when the currency chokes profit. Attuned to the hard-edged logic of business, we might not be moved to dwell on such states of transition any more – until a company relocates and takes the hope and distractions it brought for regeneration with it, or until a remote building collapses around textile workers in Bangladesh, drawing into focus the thin and hardly regulated strands that keep Western chain stores tied to their profits, as both profit and transparency are temporarily compromised. Communities that once made something – or mined something – may no longer work those regular shifts before returning to the homes built close by, to convenience that very purpose. Regions are changing to take roles between manufacture, service, and heritage and are compelled to engage with the inevitable impermanence and restructuring that follows.

We are slowly becoming naturalised to such instabilities and the rhetoric that attends them. We are wary of neat answers; we grow tired of politics and promises and seem to have grown distracted by interests close to home. We focus closely and dwell on our own lives now, photographing at the slip of a wrist, because photography is everywhere, ubiquitous, though often forgettable. Our communities are as virtual as they were once external; we can be preoccupied now with looking in instead of looking after – we're fluent yet fearful, educated yet uncertain, with a tendency to pull closer, in ever smaller circles of trust and co-operation. We are more conscious of, it would seem, if no more ready for (or resistant to) subterfuge, in all its forms.

The persuasions that vie to control the message at the heart of working life have long lost their openness, their naïvety (if naïve is what they ever truly were) – and photographers, we might understand, have had to negotiate such a world and make sense of it accordingly. Just as the reporting of conflict has become so managed in recent decades, a more interpretive 'late' photography has emerged. It counterbalances the medium's relationship with the viewer and outlived a recent dalliance with vernacular, faux-subjective practices, to return to architectural stillness. It is willfully slow and considered, often working outside the immediate field of engagement, drawing instead upon preparation or consequence, ephemera and evidence. It is a kind of photography that draws from archaeology, aspiring to reach tensions beyond the surface and assess the fragments through multi-vocal enquiry.

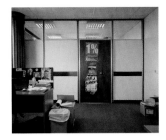

Services, Industrial
Professional & Technical Union
SIPTU | DUBLIN, IRELAND

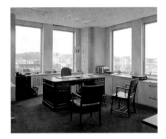

United Electrical, Radio and Machine
Workers of America
UE | PITTSBURGH — PENNSYLVANIA, USA

We have reached an oblique and mixed-up moment in the medium's development. On the one hand, it can draw on the contemporary possibilities of scale and reproduction whilst remaining reserved and artisanal – indebted, as it seems to be, to the measured clarity of early modernism. Drawing from photography's slow and peerless contract with time, it can sensitize the most subdued locations before asking us, should we ever have the time to pause awhile in this brisk world, to think, not just about what's going on… but about fate.

Noel Bowler's photography has followed a steady migration to the still interiors he now records. In the early years of the new century, he made a long-term study of the Mountjoy prison in Dublin. There is warmth and co-operation in the pictures he made with prisoners. He is accepted, trusted and there is a sense of engagement and humility as he photographs at knee-touching distance. In one photograph, a prisoner sits waiting for a visitor. His age is hard to define, his appearance inflected with fluorescent light and the pallor of prison time. The photograph is an aching and affecting admission of human fallibility, made all the more human against the stale, cream brick room, where the encounter will take place. In subsequent work, and perhaps influenced by the Irish photographers Donovan Wylie and Paul Seawright, with whom Bowler studied and later taught in Belfast, the interior itself came to dominate. How a space can betray something of those who would normally populate it has been a contention throughout the history of photography. From its earliest moments, the limits of the medium's sensitivity meant that descriptions of working life and working people's homes remained rare in 19th Century practice. These absences were bridged, but not wholly filled, by pictures made to mark workers' holidays, mass celebrations, and occasional leisure interests – events, we might note, recorded by those who had the means and liberty to photograph. In 1936, Walker Evans' photograph of the Burroughs family's bedroom would work to cantilever splintering austerity with a sense of the ordered integrity of the working family who slept there. In spite of their absence, it would seem, lives can be laid bare. In the series 'Making Space', Bowler went on to photograph rooms used for Muslim prayer in Ireland. Now architecturally precise, the photographs would render the modest adaption of unorthodox spaces into places fit for prayer with a mature, refined economy.

…but what of the people? They remain of course, living, working, praying, keeping on. In Noel Bowler's latest photographs, union workers are often represented through their rooms and the materials they gather, as they negotiate the institutional spaces, of which they are the most recent custodians: A paper cutting of Marx is pinned next to campaign flyers and personal details on a desk partition in a Dublin SIPTU office. It is a mood board of sorts, with tokens built over time, serving to shield and insulate, as much as it is a reminder of purpose, belief, and family matters. In Pittsburgh, a telephone is the only modern concession in the antique, wood-warm office of United Electrical, Radio and Machine Workers of America. A room with a view, it boasts an elevated authority over a city and the adjacent stadium. With height comes knowledge, status… power… As the song goes, there is indeed still power in a union.

Power now rarely manifests as a binary tension that positions a factory owner's pay offer against a community's rejection song. Throughout the 1970s and 80s, some theorists would rekindle and reflect on Antonio Gramsci's prison writings, particularly the theory of hegemony, by which control can be imposed without a public ever fully recognizing the coercion at its heart. In dismantling regional identities, by forwarding a sense of the single, family unit as the value that should be protected beyond all else, years of decline in community cohesion across the international industrial landscape would progress. Historians and writers interested in photography would return to the texts of William Stott and, later, Jeremy Seabrook, to ask: 'Is it possible to photograph a condition – something as much a psychological state as a direct action or a mark on a surface?' Surely, they would contend, those photographs that recorded the ship's launch or the factory outing only ever amounted to a partial account, more an irregular note in a workforce's year than a more sustained heartbeat.

Photography, once a witness, has become an interpreter, since it relates a world conscious of the currency of its own image and is anxious to drive agendas on its own terms. In Jaqueline Hassink's 'Table of Power', a book in which the Dutch photographer attempted to photograph the unpopulated boardrooms of successful multinational companies, her contention – that we might understand something of the mindset of the companies themselves by looking at the spaces where the most telling decisions are made – was all the more effective on the occasions when her access was denied. The refusal was duly noted in her book by blank pages. How nervous those companies must have been of photography's ability to glean traces of policy, philosophy, or even character from the fabric of a vacant room. Whilst Bowler's presence is more philosophically aligned to the work carried out in these rooms, his approach might also move us to recall the photographs of Lynne Cohen and Lucinda Devlin, who, amongst others, began to explore the institutional interior in the 1970s, work spaces that commanded the reverence of church interiors or the suspicion of courthouses. Their interior geographies allowed us to imagine and invest – to consider the impact of decisions made in those spaces on lives that, for a few moments, disheveled them of their institutional neatness. These were still and sometimes graceless rooms, where money was made and spent, where knowledge was taught, where sentences were passed... where wars were strategized. Rarely benign, such interiors could be benevolent or instructive, fateful or final.

Against such foundations, Bowler's carefully rendered scenes and the representatives he occasionally portrays are at the heart of a movement that works for the just representation of working people. Whilst some organisations occupy the simplest of functional spaces, others confidently demonstrate their rootedness within the established order of things, with some owning, as they do, significant real estate at the heart of their country's political geography.

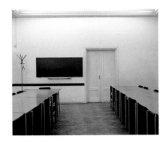

Union of Polish Teachers
Związek Nauczycielstwa Polskiego
ZNP | WARSAW, POLAND

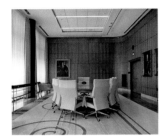

International Brotherhood of Teamsters
IBT | WASHINGTON, D.C., USA

The ZNP Union of Polish Teachers will convene in what is, in every sense, a classroom, while, at the International Brotherhood of Teamsters in Washington, D.C. (where even the chairs huddle in conference) the only distractions from the business at hand are portraits of esteemed former members and the clearest view of Capitol Hill, the heart of America's political system, just a stone's throw across the park.

Throughout the seasons when parliaments are in session, TV political debate programmes often run late into the evenings, when what used to be known as the working week nears its end, when tiredness overtakes composure and the risk of practiced speakers falling off-message becomes a real possibility, the power play between politicians, journalists, and union leaders can often become a breathless battle for hearts and minds. It's rehearsed, yet fragile and faltering. It can be blindly partisan and self-absorbed. Answers will evade questions and, in turn, become accusations. Figures are cited and traded, manipulated and returned, to finally mean nothing as panelists trade jowl- (or pinched-) faced jousts before braying audiences. The political representatives, it would seem, have all too often become a distant and scripted deflection… There are few real answers.

There are, however, on those late evenings spent channel-hopping for hope, rare moments that can sound startling notes of integrity. When just one decision can break apart a family, a workforce, a region, those who speak as union representatives seem charged with the most urgent task of code-breaking, translating the doublespeak to hold practiced opponents to account, through a few brief seconds of principled and dignified resistance. Such reason has been shaped and refined in the rooms we are introduced to here. As I look at these pictures, recognising Mark Serwotka and the late Bob Crow (who, in their time, had been regular spokesmen and no strangers to political debate and its wounding personal hostility), I am reminded of those late-night arguments and anticipate the battles still to come – and I think Noel Bowler does too. He's dwelt on the rooms where decisions are made, where arguments are resolved and cases assigned. He has recorded the spaces set to plan for overturning waves of apathy and the decades of attrition that those organisations that speak for labour practices have encountered and weathered. When responses to the slippery world of false front and favour are negotiated as though on a sea yet to reveal its worst swells, it is heartening to spend time with Bowler's quietly anchored work, to recognize the value and richness of all these sustained labours and understand that there are still sharp minds and strong hands ready to navigate difficult waters.

Ken Grant

Section ___/___ No. 19

FULL MEMBER.

1940

Shop Stewards are authorised "to examine at least once a quarter the Contribution Cards of all members" (see Rule 13, Clause 17).

Any member commencing work shall, in writing, inform his Secretary within 48 hours of starting, and if such work is in another district apart from his own, shall also inform the nearest Secretary within the same period, and also give his rate of pay within three days of receiving same, or be fined 1s.

No Secretary is allowed, under penalty of 5s., to receive members' contributions out of branch meeting, except sea-going members, and such as are remitted by post, which shall be paid into the branch on the next meeting night, such sums to be then inserted on the member's card. Any member, or person acting on behalf of a member, disregarding these instructions, shall be responsible for such neglect. The Union accepts no responsibility for contributions paid in contravention of Rule 7, Clause 12.

Postal Orders sent in payment of contributions must be sent to the Branch Secretary and crossed thus /-/, and made payable to Amalgamated Engineering Union. Members wishing their cards returned by post should enclose a stamped addressed envelope.

C.P.& (T.U., 44 hours), Tudor St., E.C. 4

FULL MEMBER.

A member's card shall stand as a statement of contributions paid, but the member shall be held responsible for its regular presentation. In no case shall arrears improperly computed affect the correct financial position of the member. (See Rule 27, Clause 7.) If not produced in case of dispute, the Union's books must decide.

The number of days exempt from the payment of contributions by causes stated in Rule 27, Clause 4, must be inserted on this card in the quarter they occur.

Members are exempt from Levies in proportion to the number of days on benefit during quarter.

Members having money to refund must do so *from their own means*, before receiving benefit.

All members are disqualified from receiving benefit if they neglect to pay in conformity with Rule 27. Members eight weeks or more in arrears must reduce them below that amount and keep same below for four weeks before being entitled to benefit. Those members whose arrears exceed 18 weeks' contributions are excluded.

☞ The date marked thus (*) is for the Annual Election of Officers; such meeting must be convened by circular.

☞ Members are requested to use every exertion to obtain work for our unemployed, and so lighten the burden of all.

1940. Section No. 12

1940.	JAN. 12 26	FEB. 9 23	MAR. 8 22	APRIL 5 19	MAY 3 17 31	JUNE 14 28	Total
Contrs., Fines, Levies.							
Received by							
Levies, etc.							Fines
‡Dist. Secy.							Pol. ‡3d.
Over Paid							Total Arrears
Days exmpt. Contr.							

1940.	JULY 12 26	AUG. 9 23	SEPT. 6 20	OCT. 4 18	NOV. 1 15	DEC. 13 27	Total
Contrs., Fines, Levies.							
Received by							
Levies, etc.							Fines
‡Dist. Secy.							Pol. ‡3d.
Over Paid							Total Arrears
Days exempt Contr.							

‡See Rule 13, Clauses 27 and 23. ‡Chargeable only to those who have contracted to pay.

PLATES

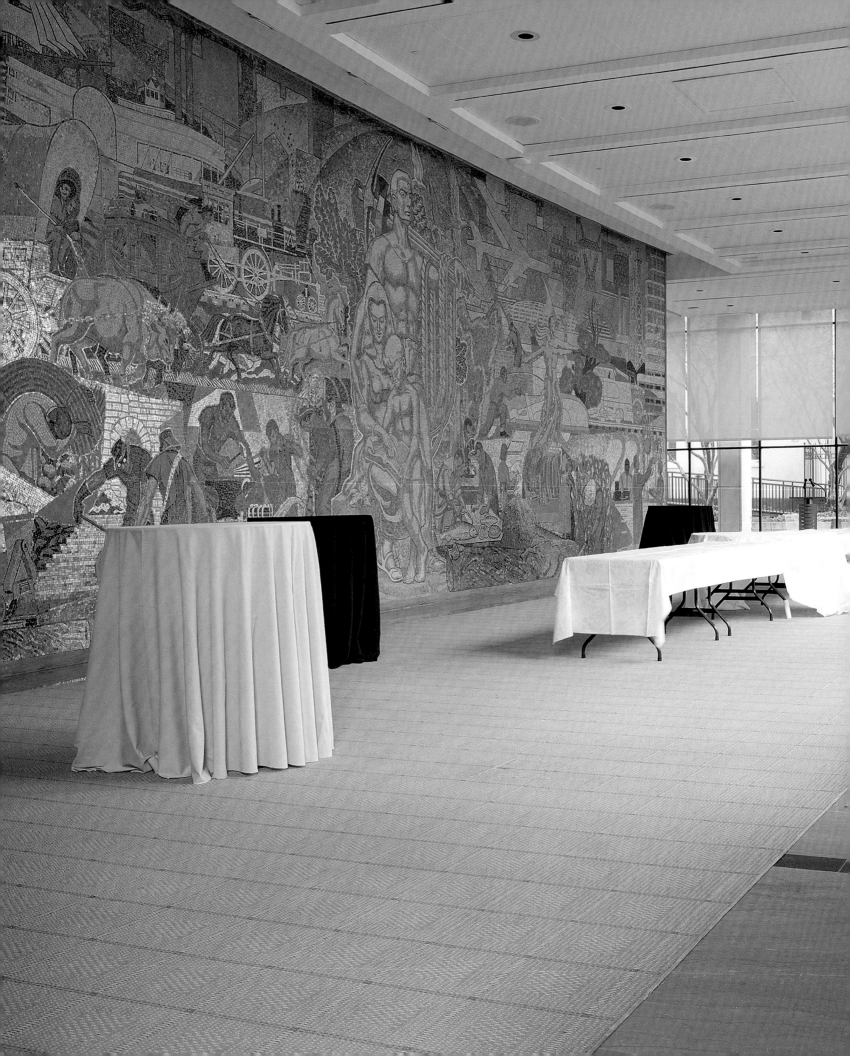

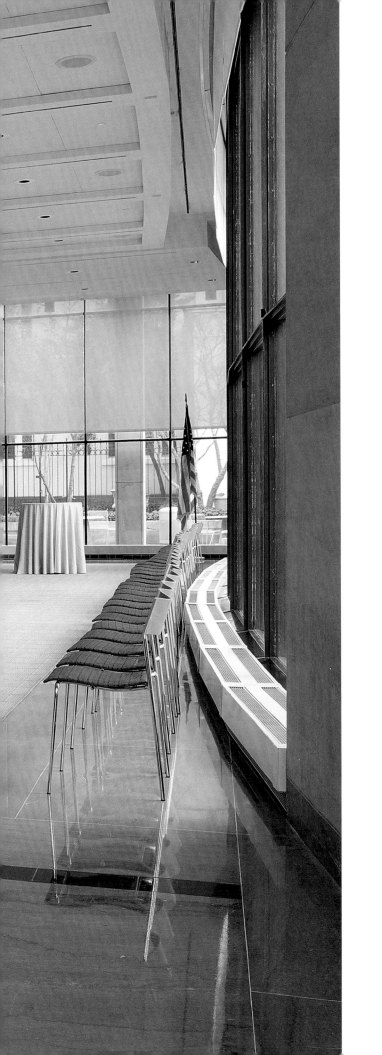

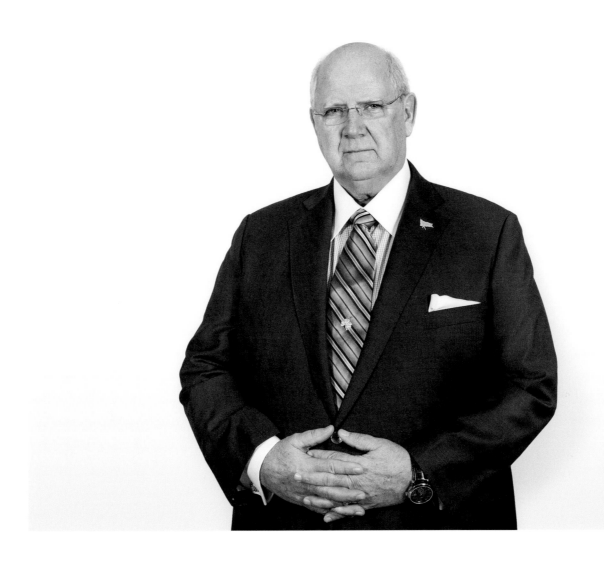

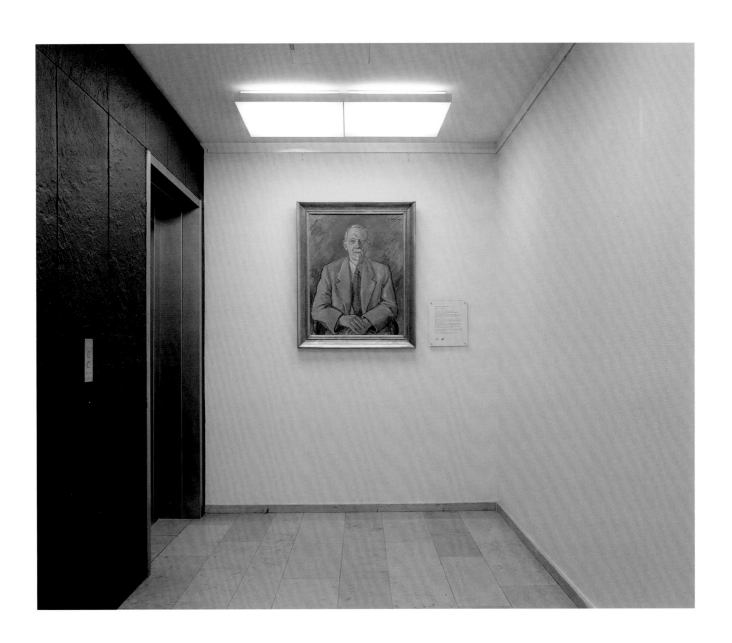

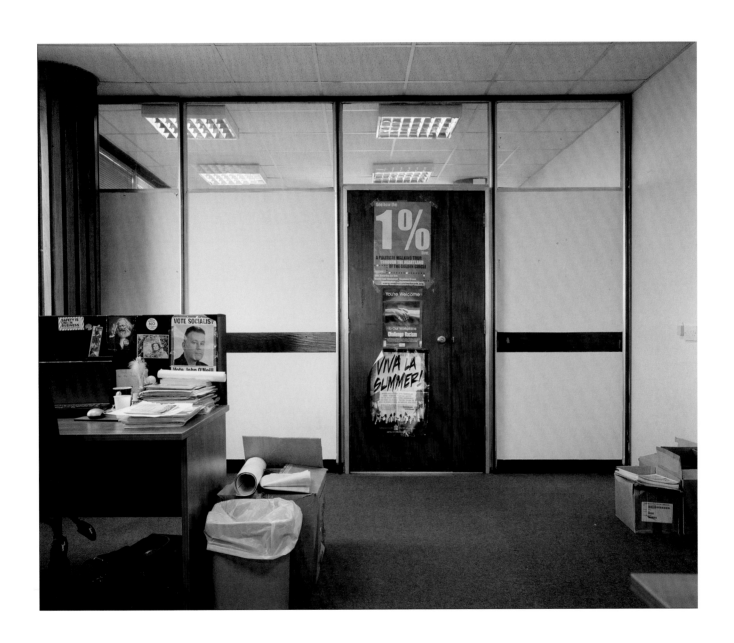

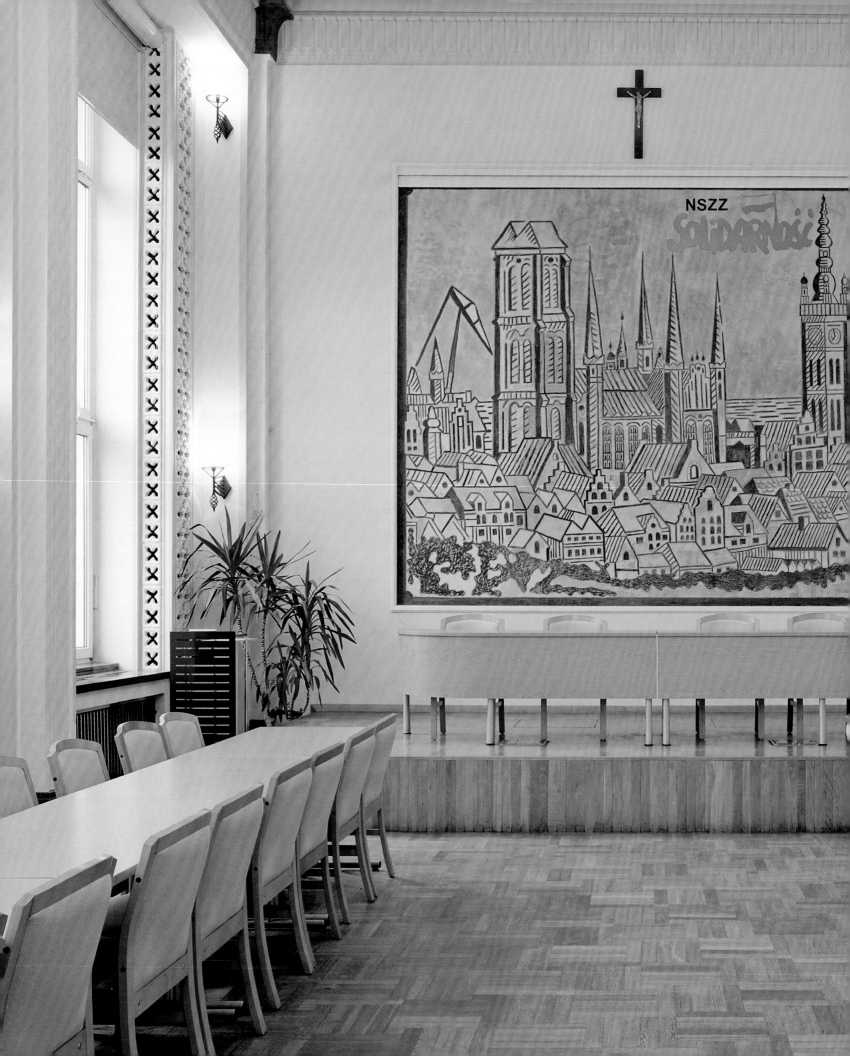

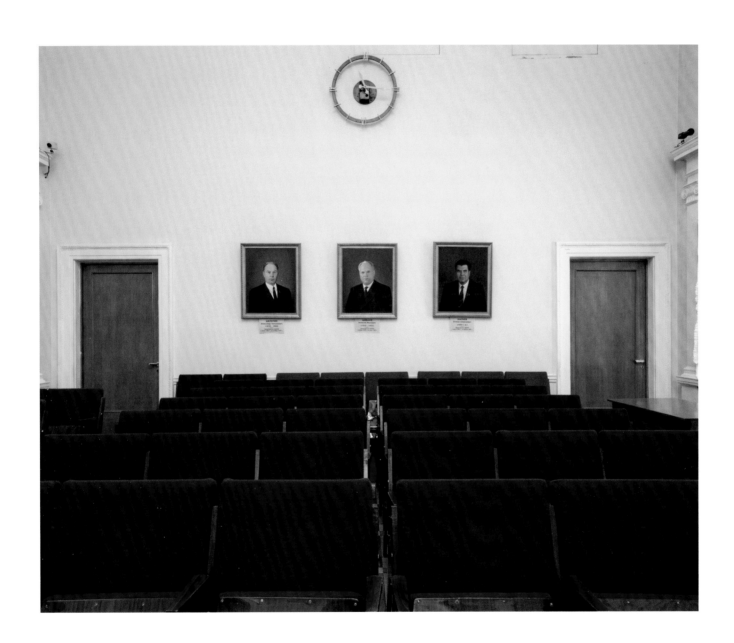

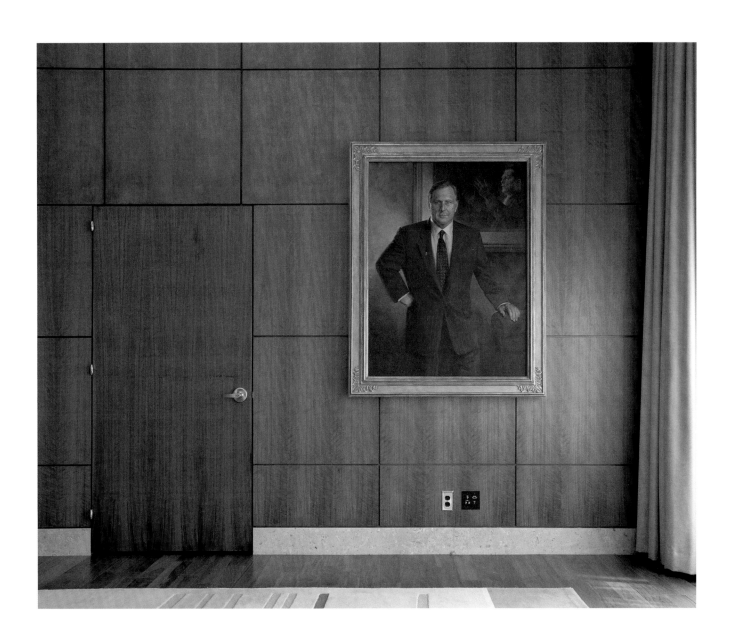

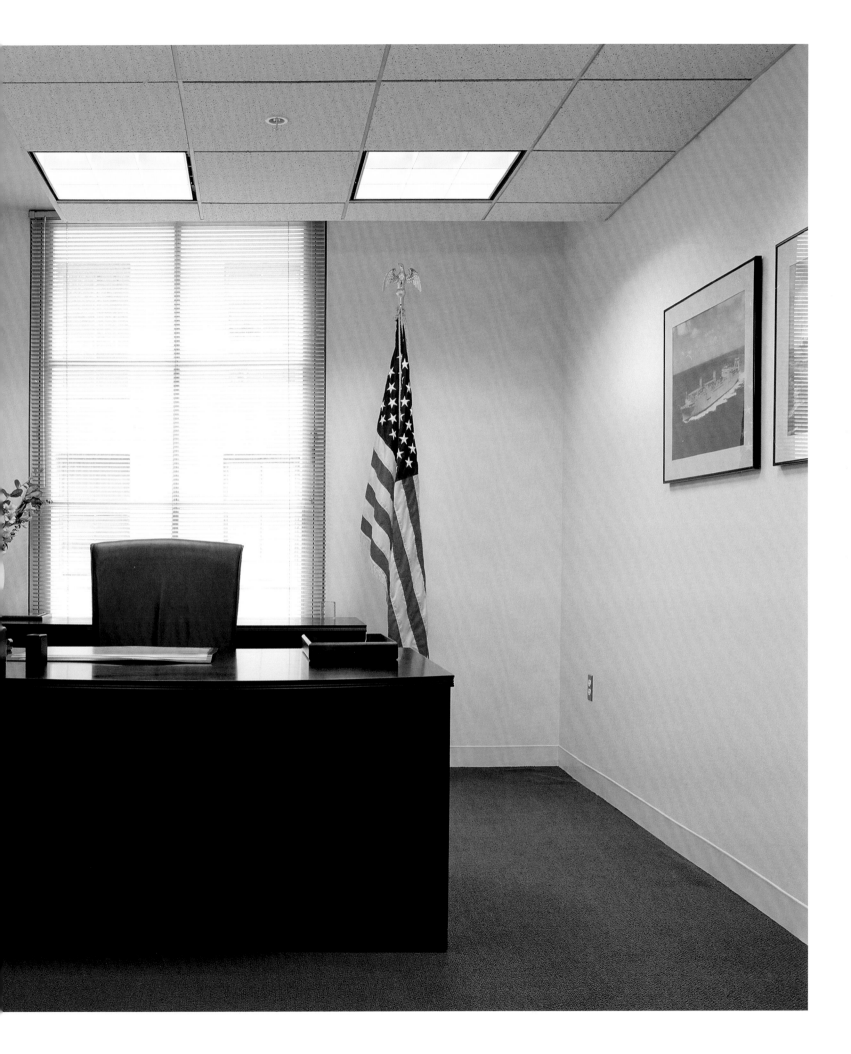

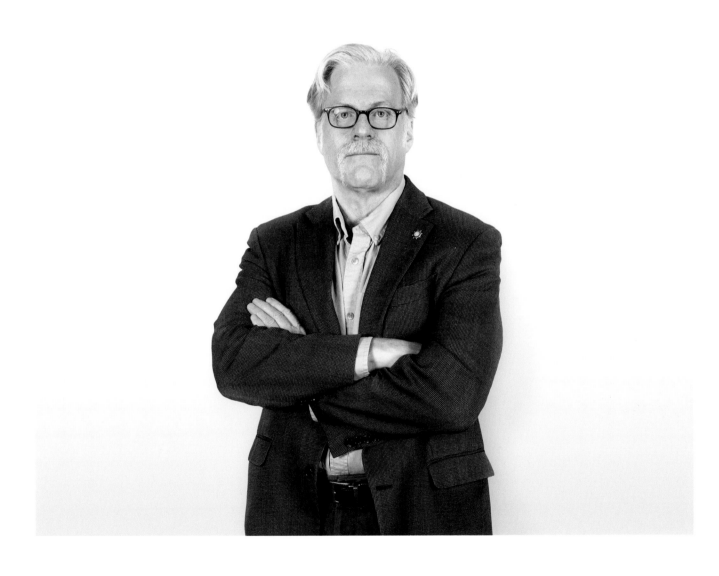

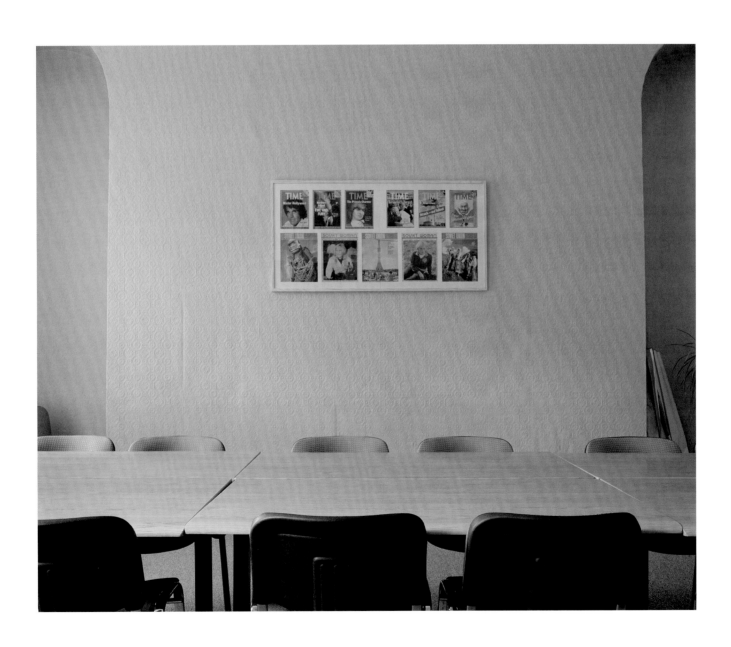

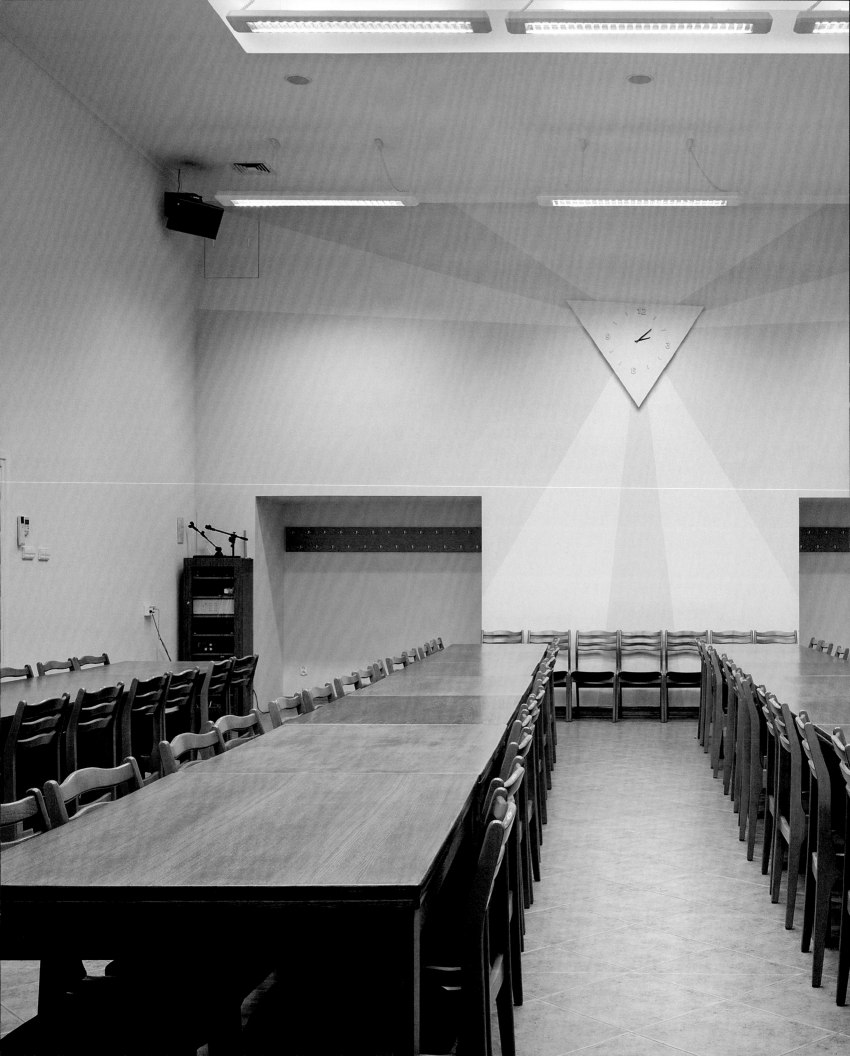

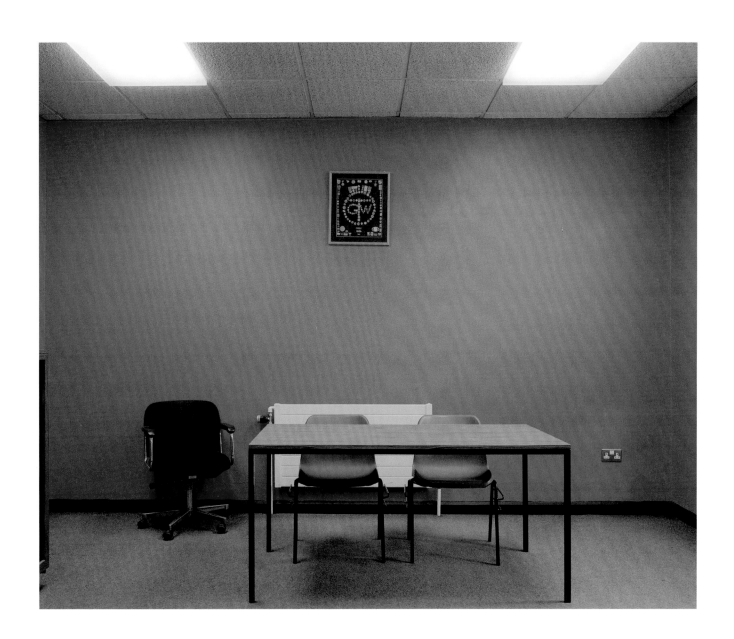

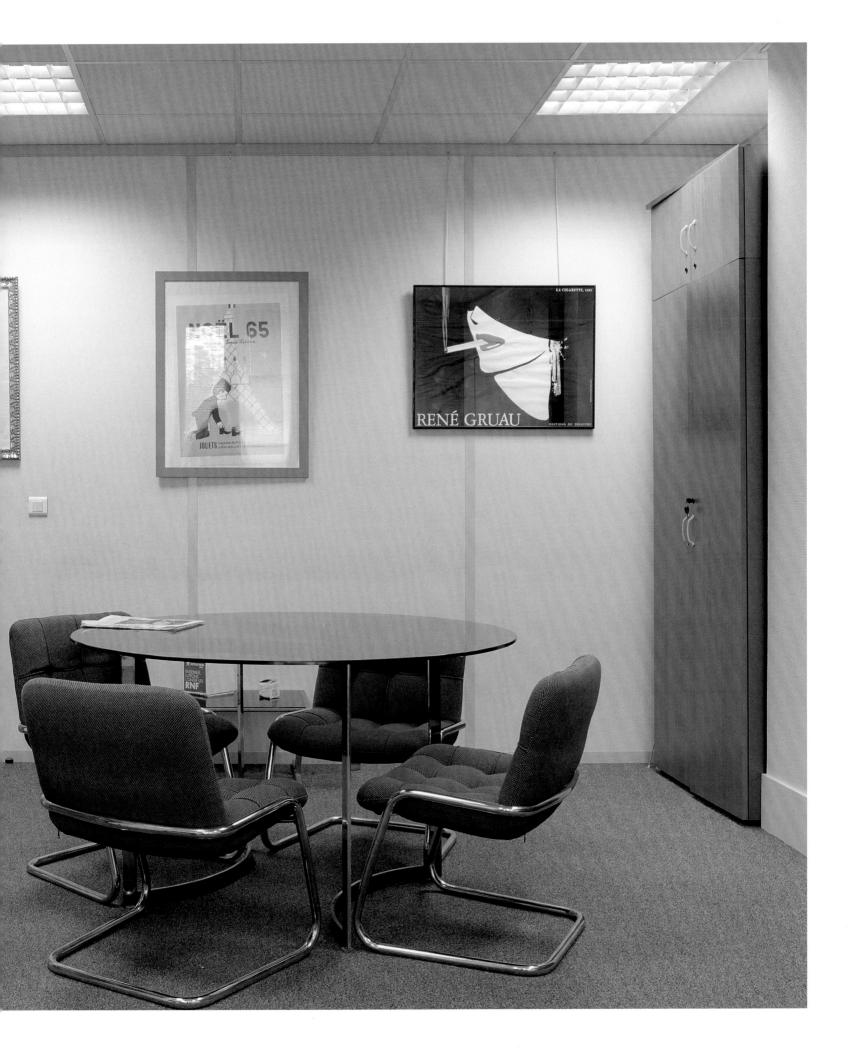

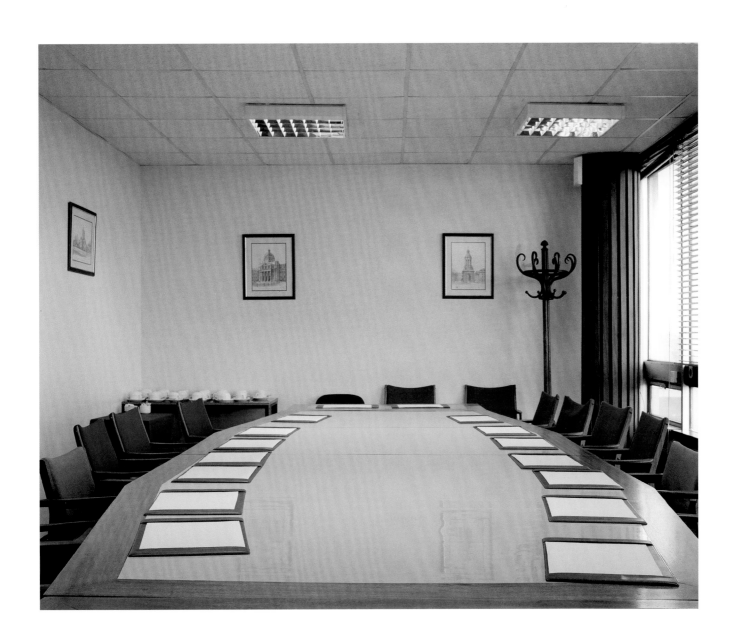

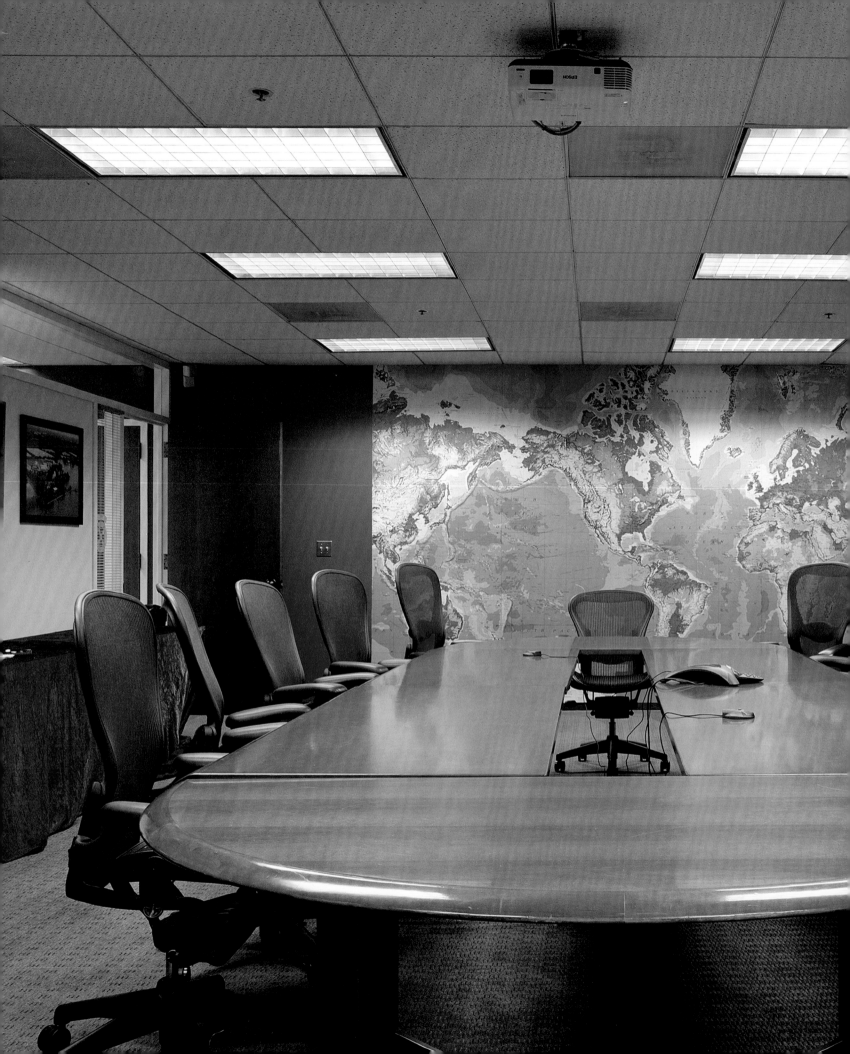

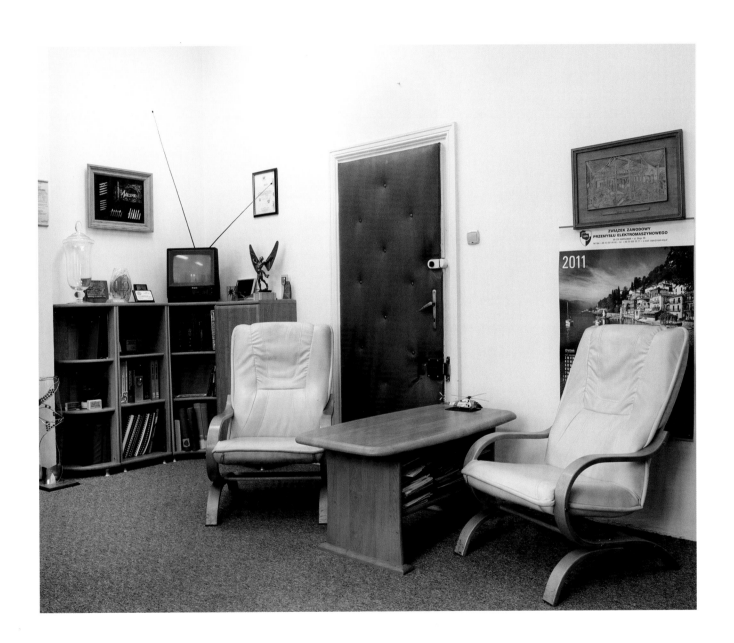

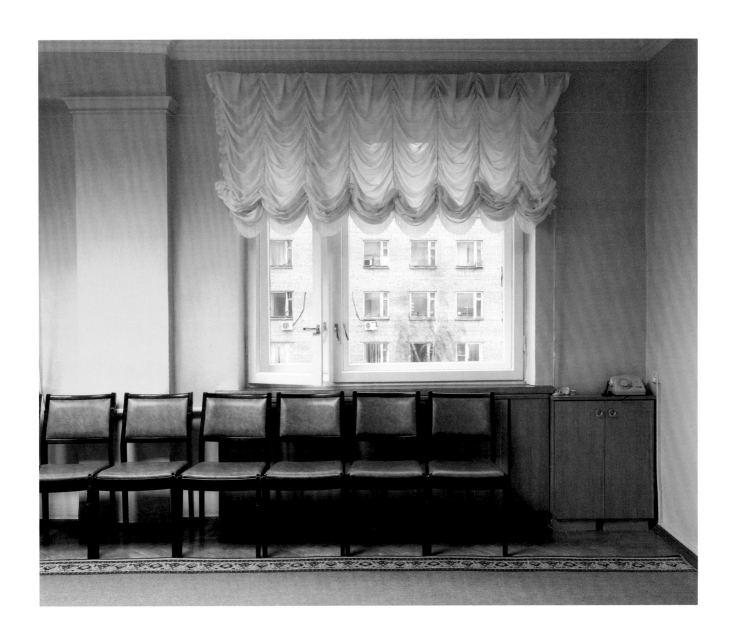

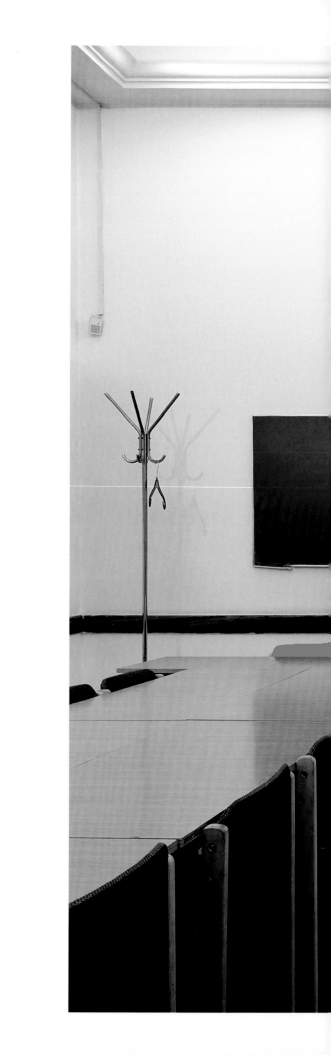

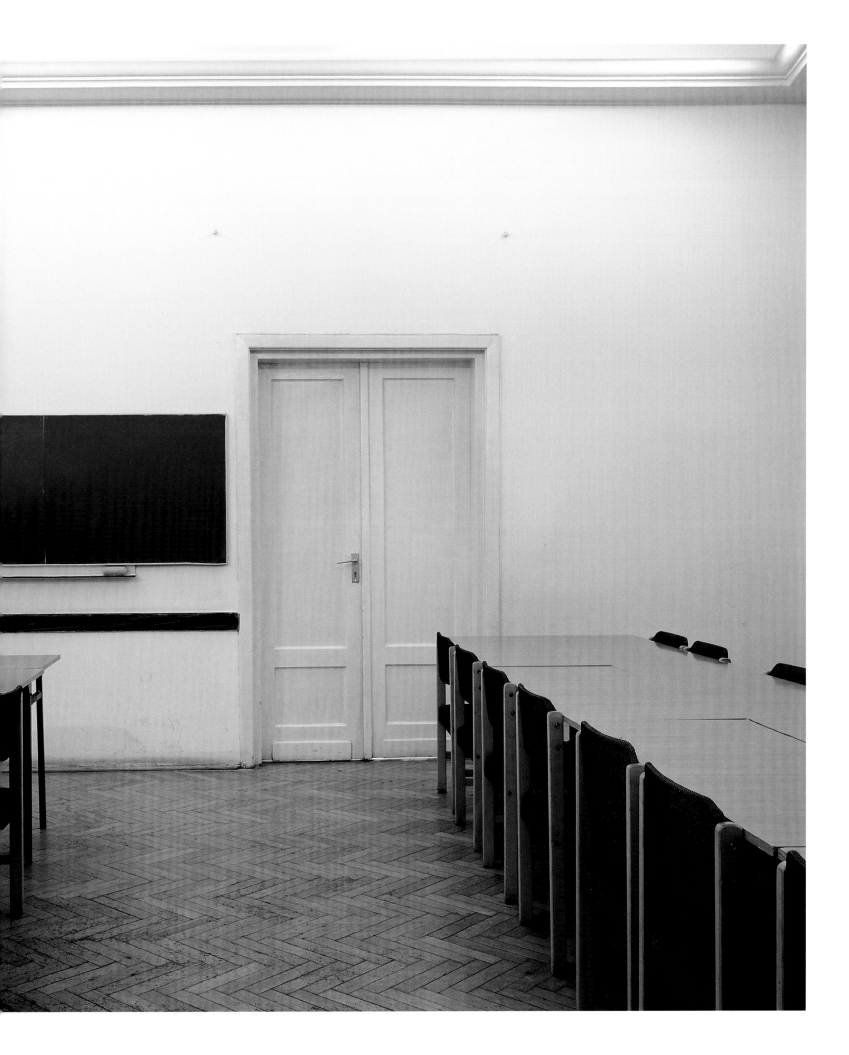

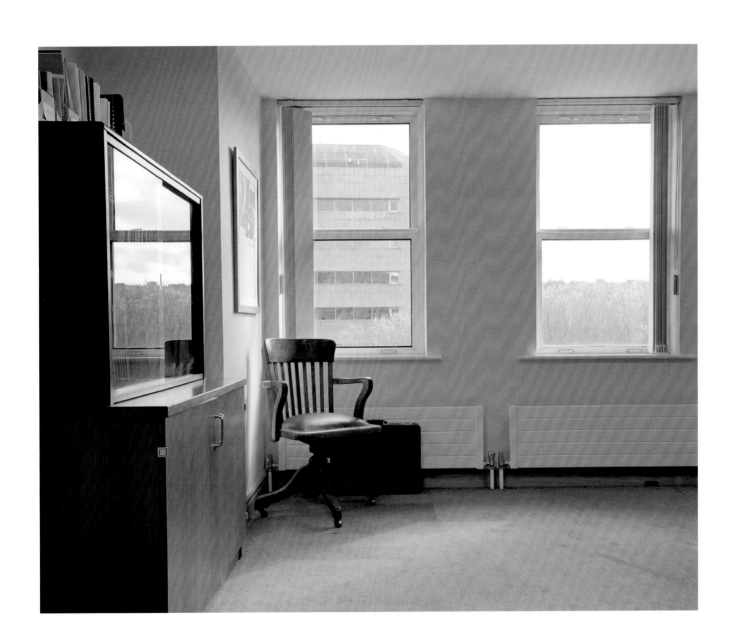

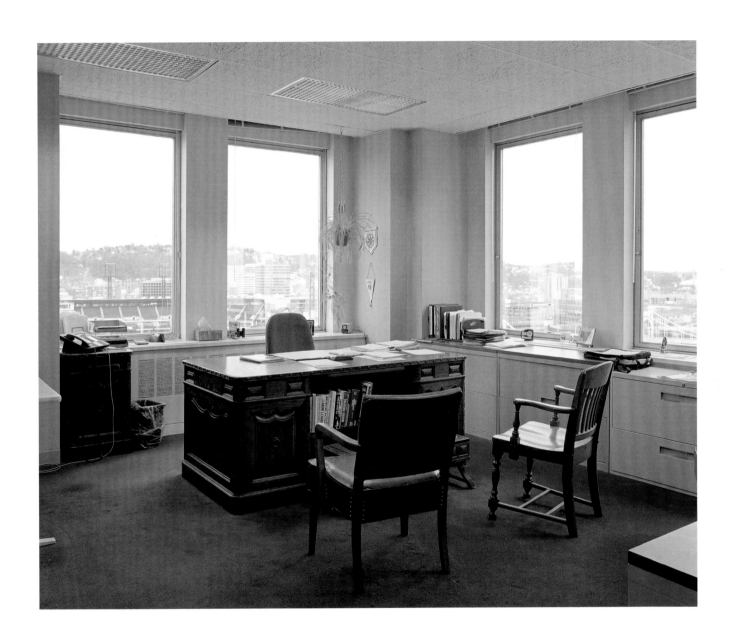

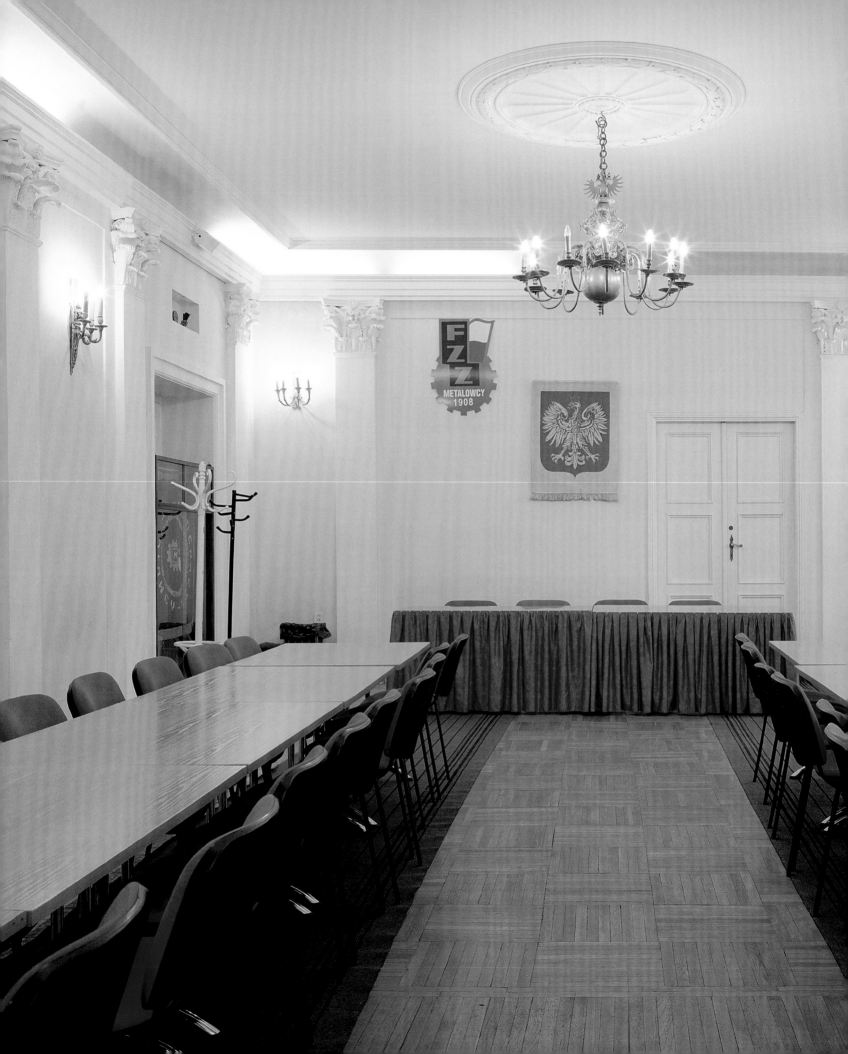

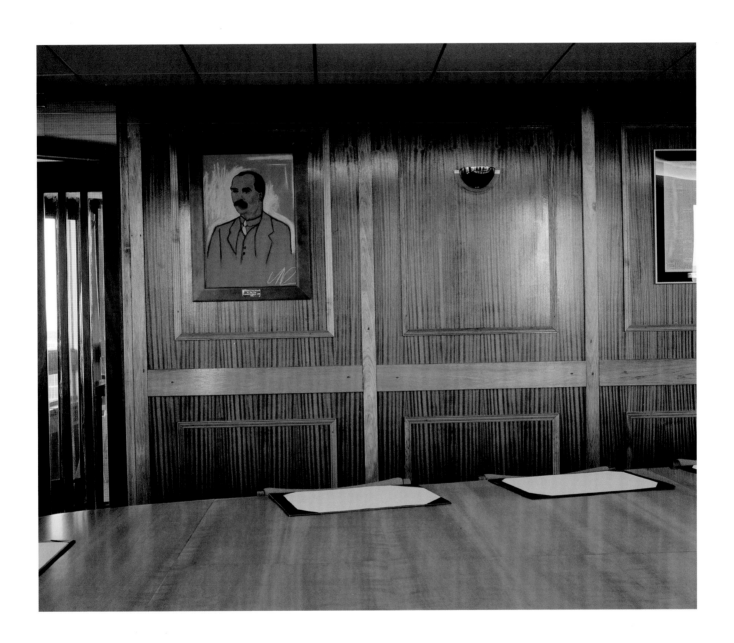

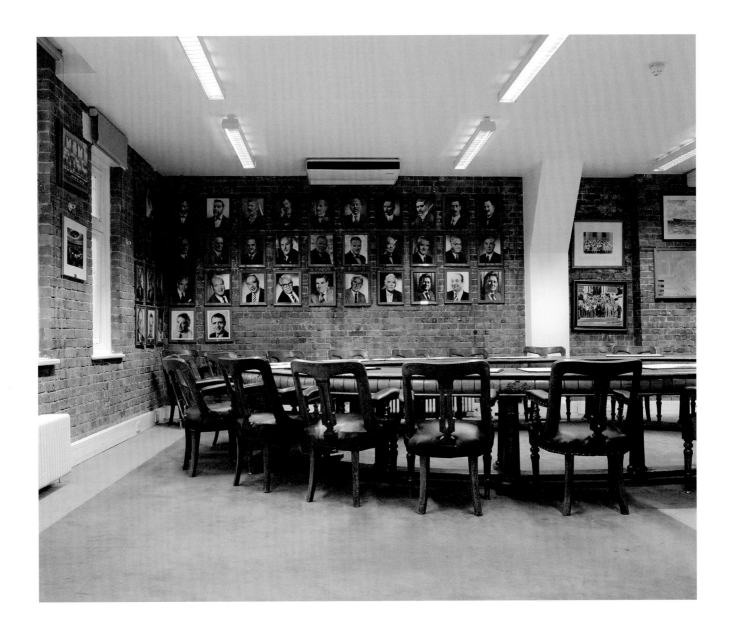

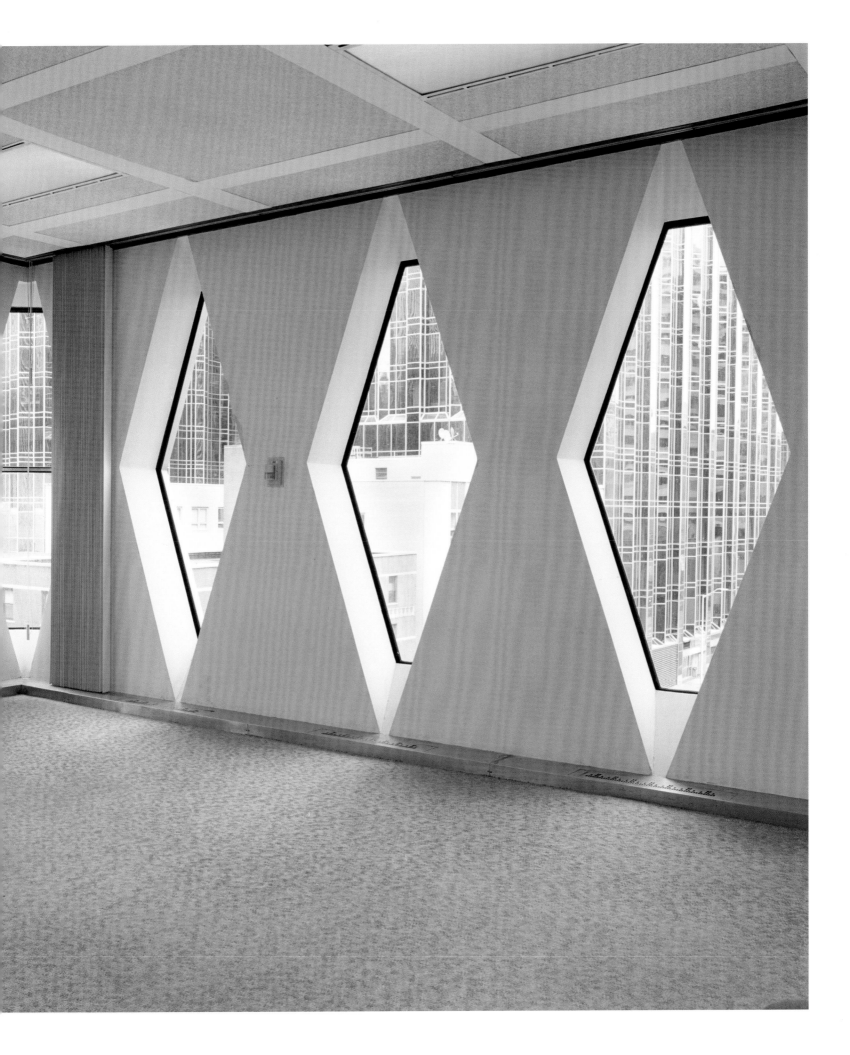

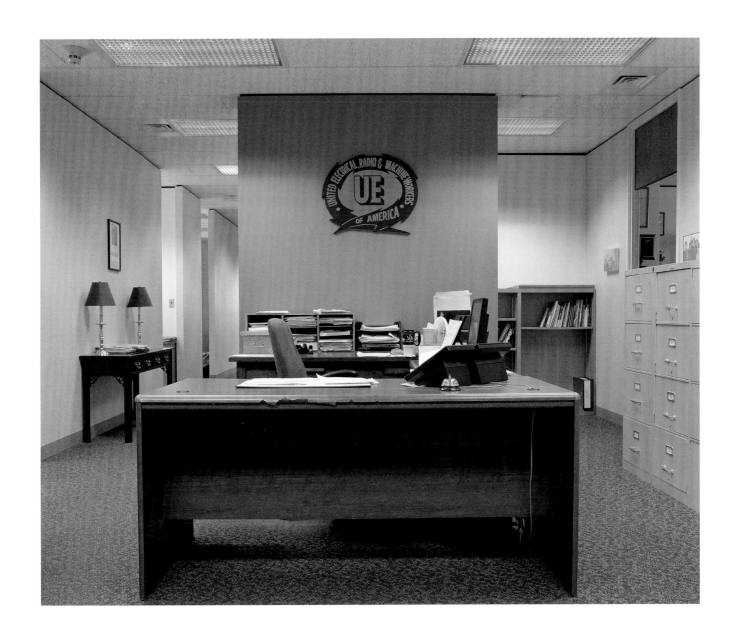

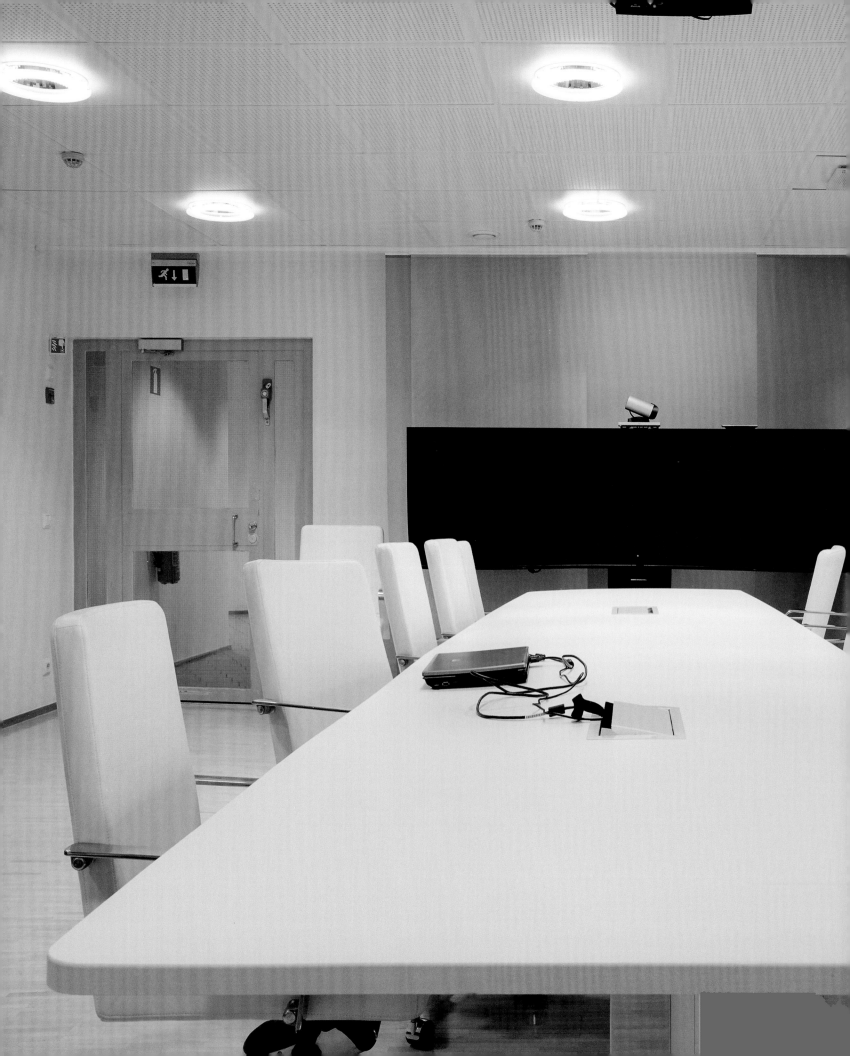

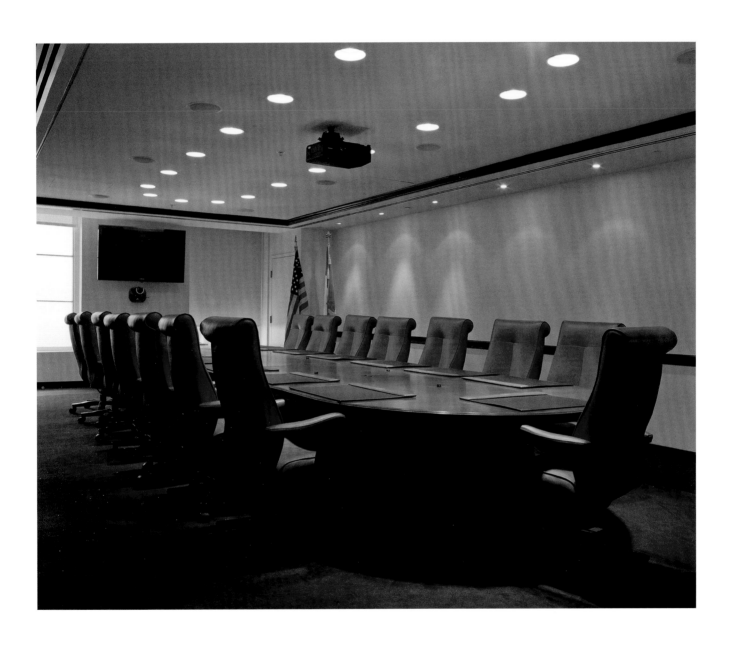

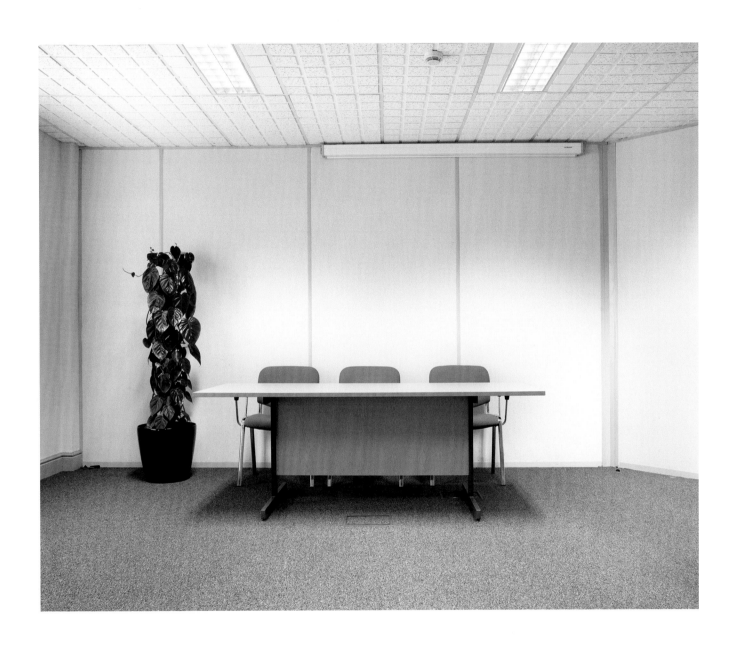

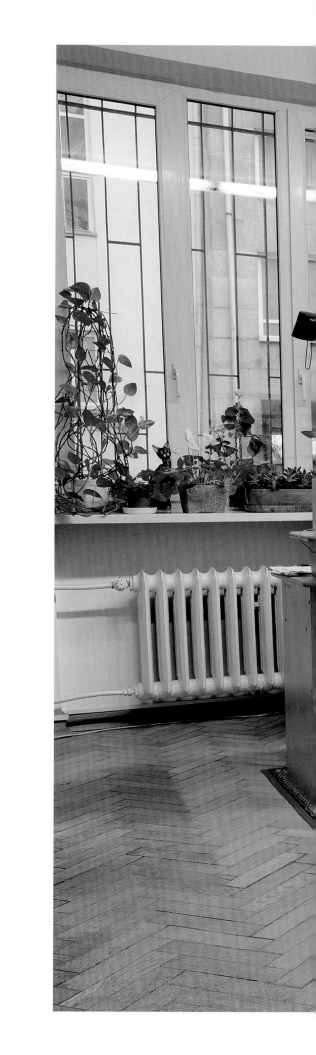

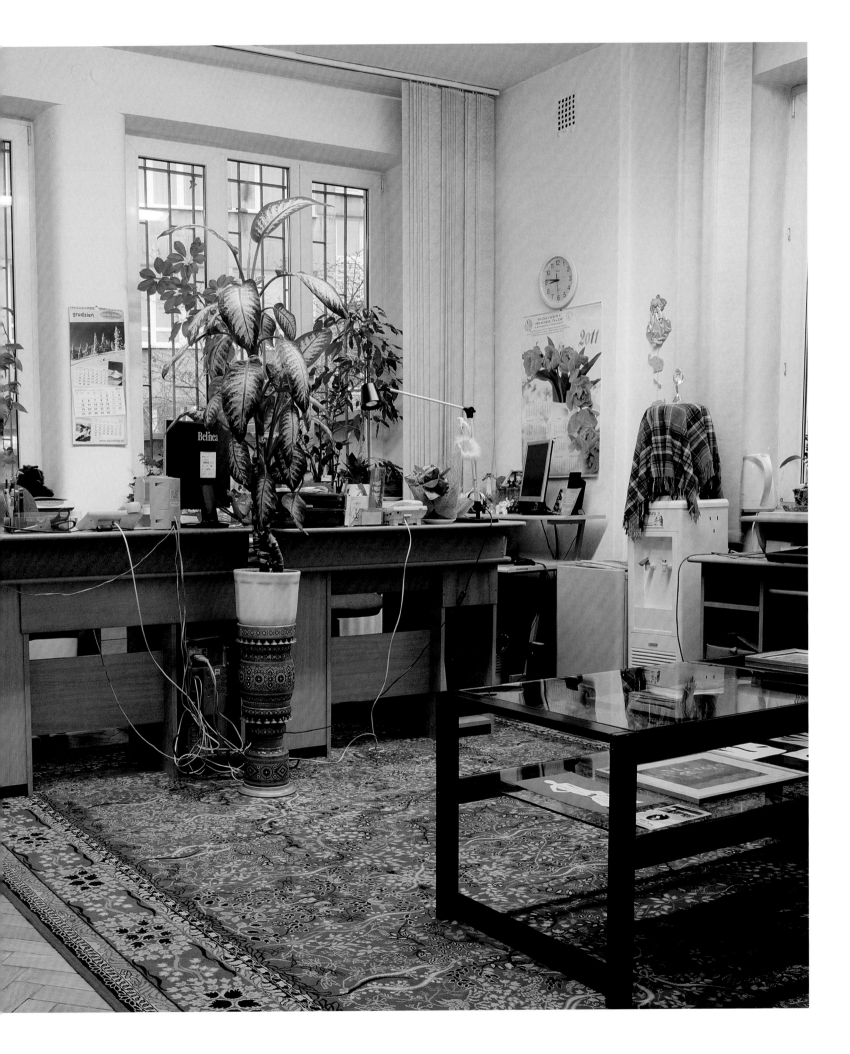

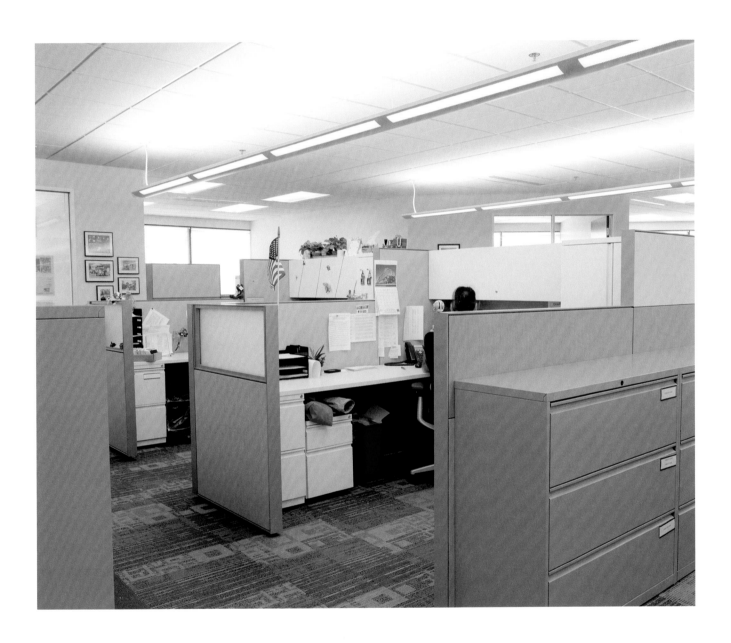

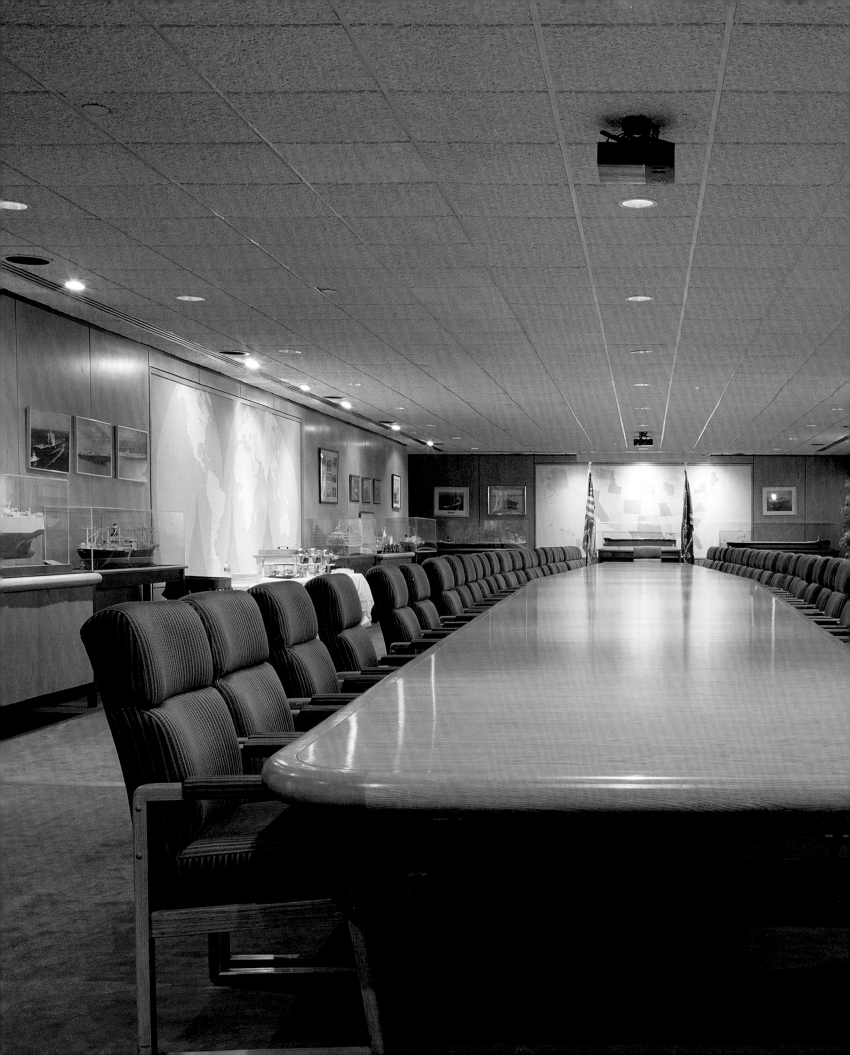

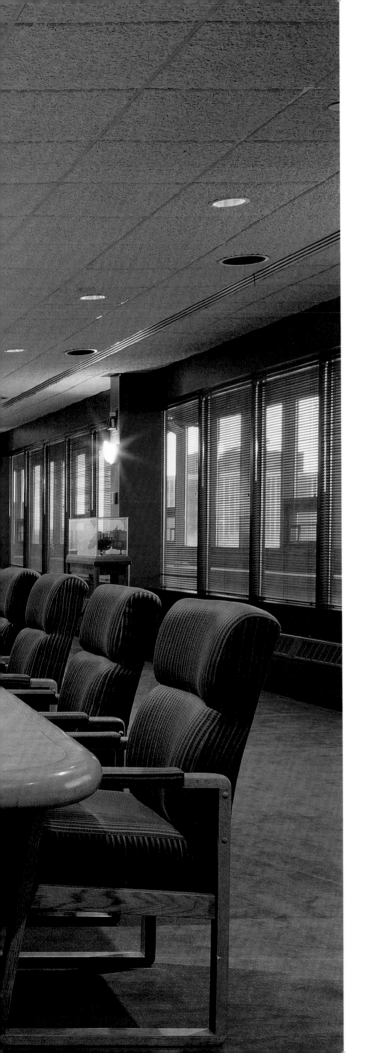

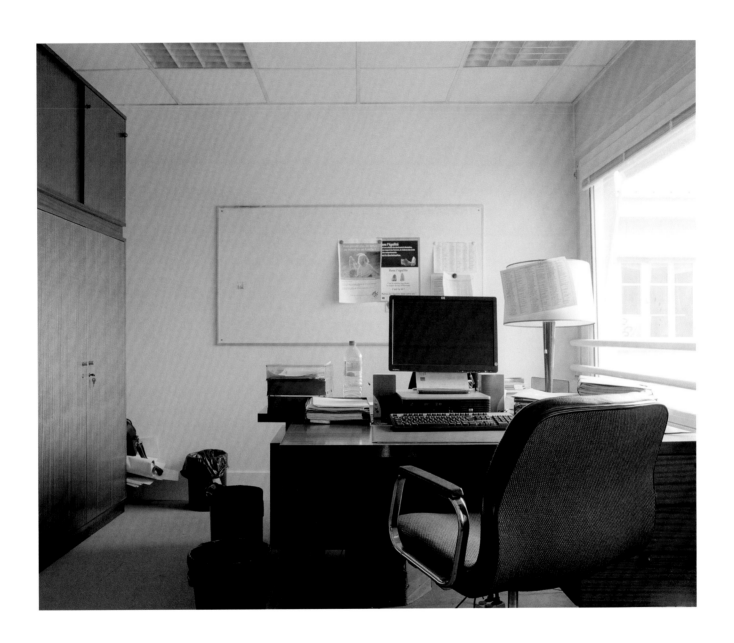

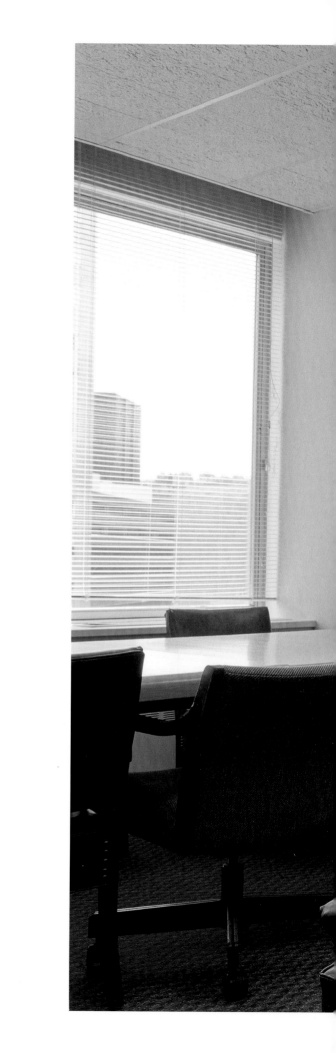

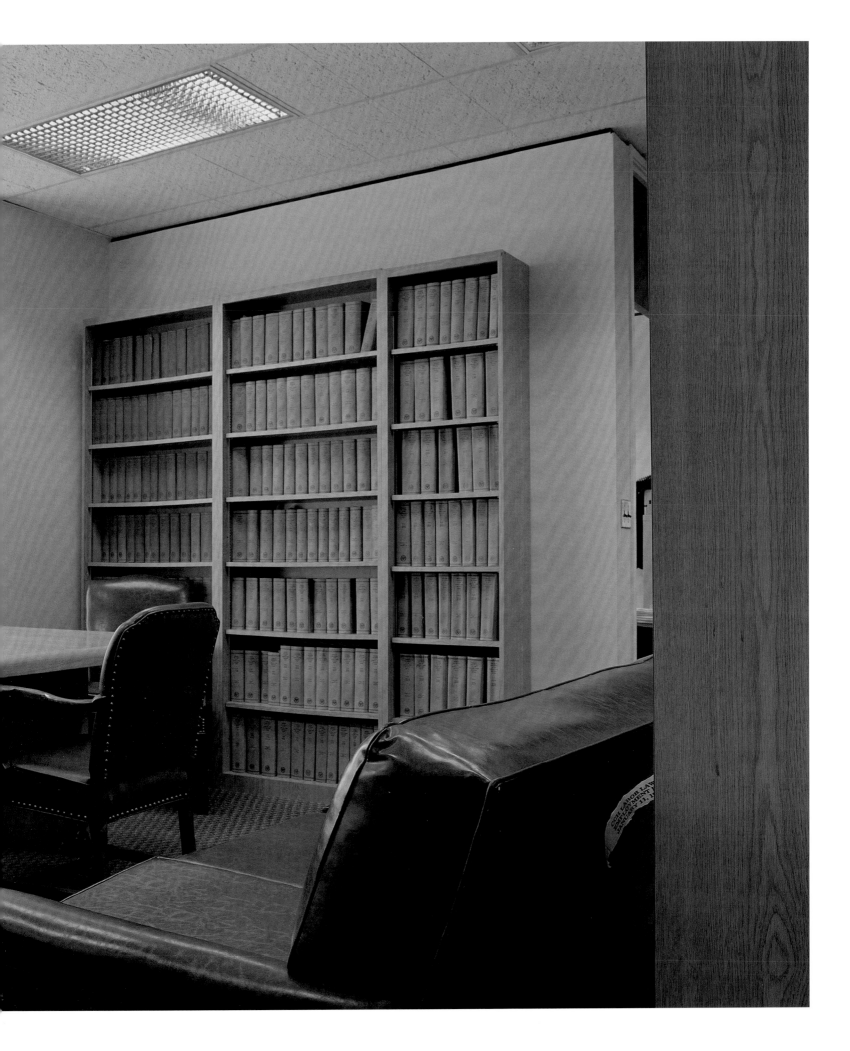

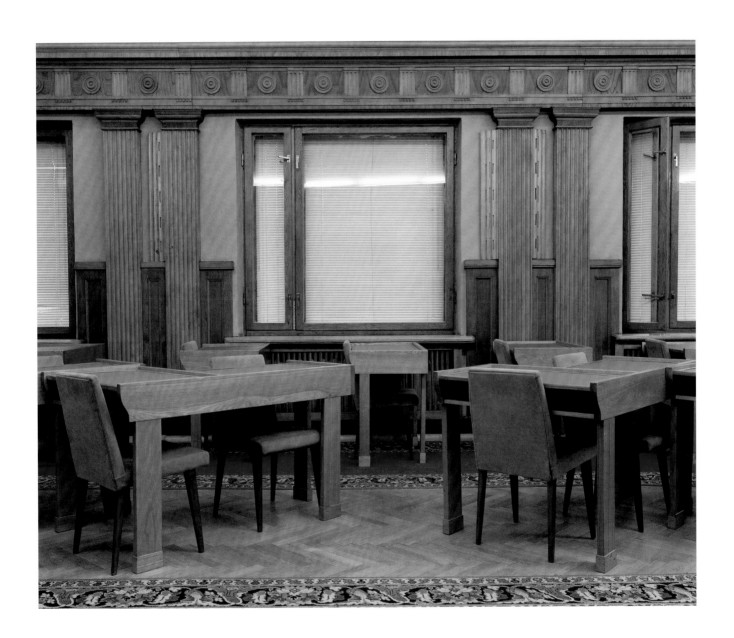

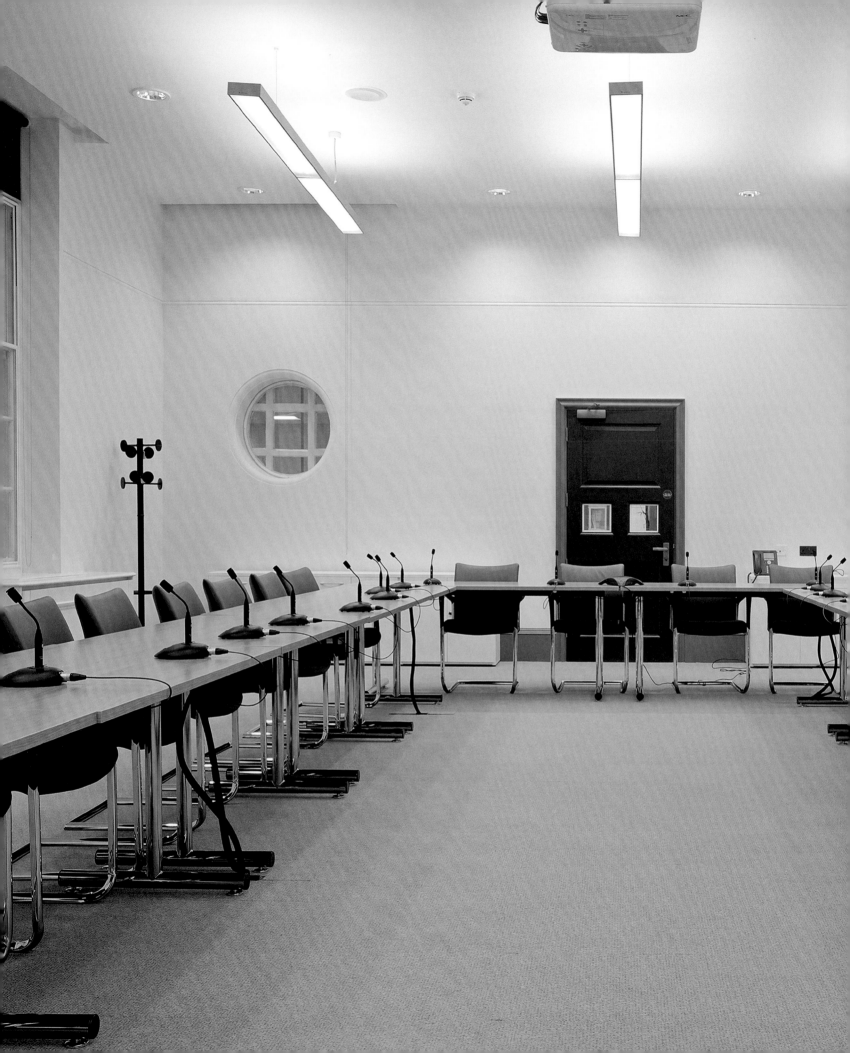

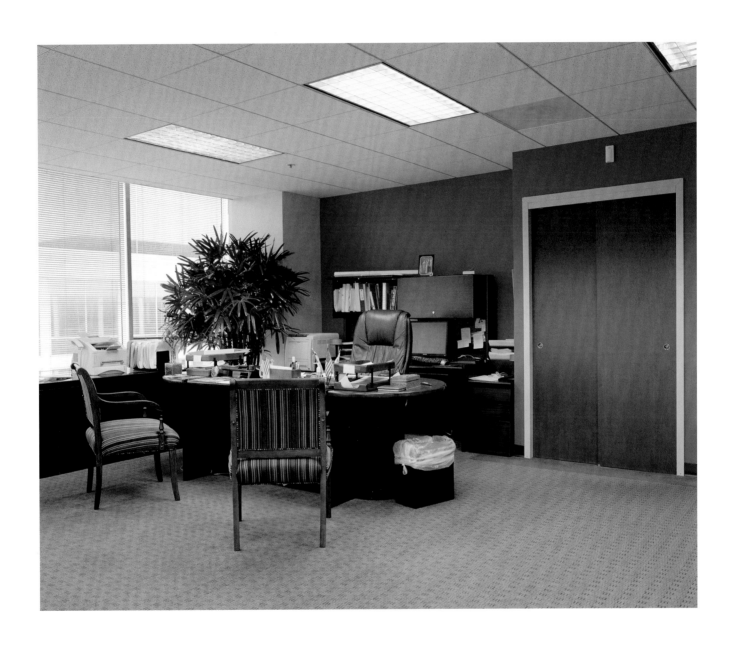

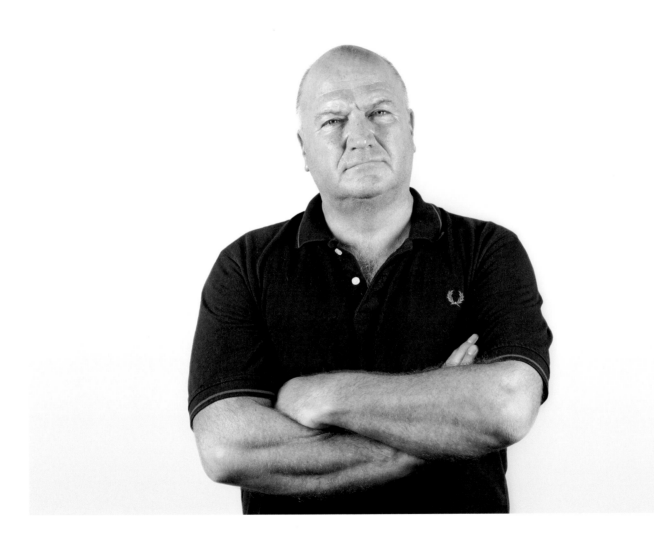

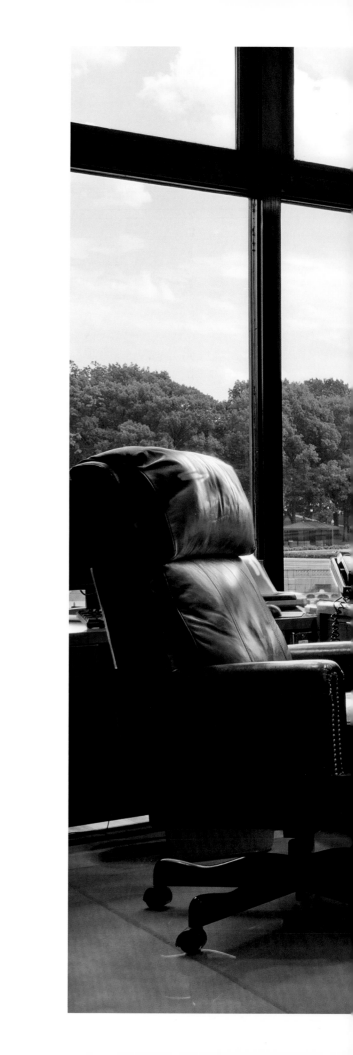

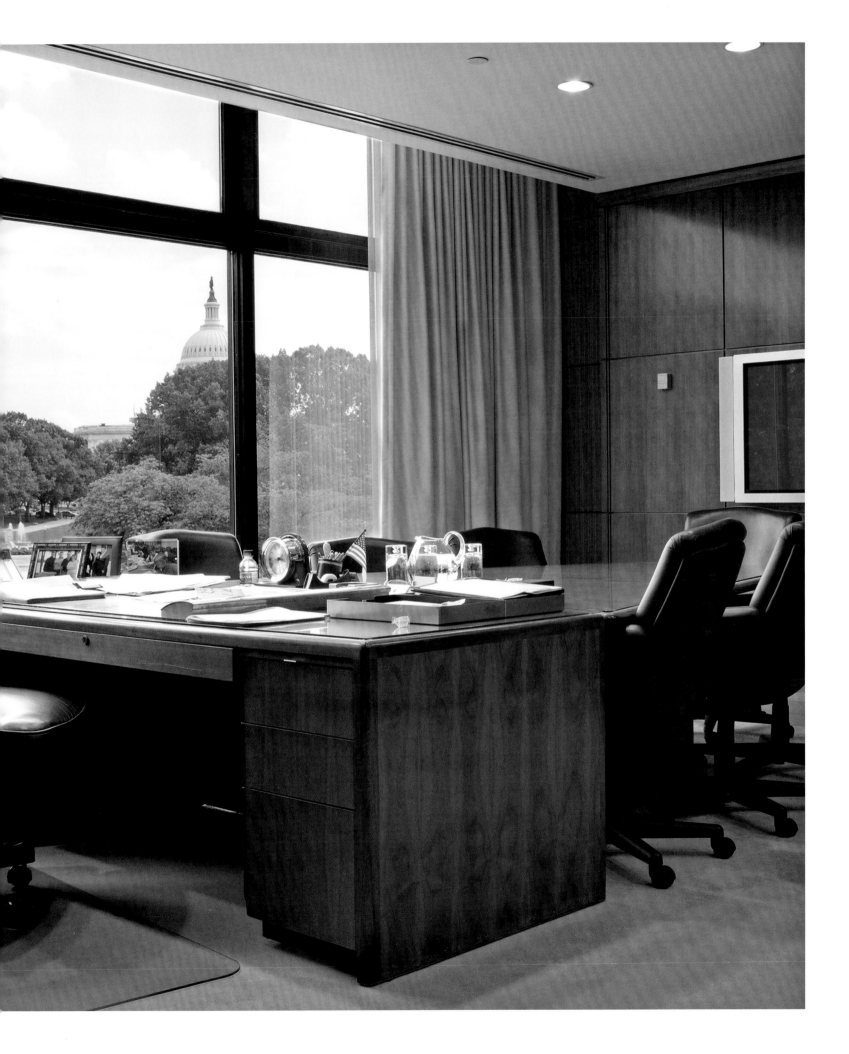

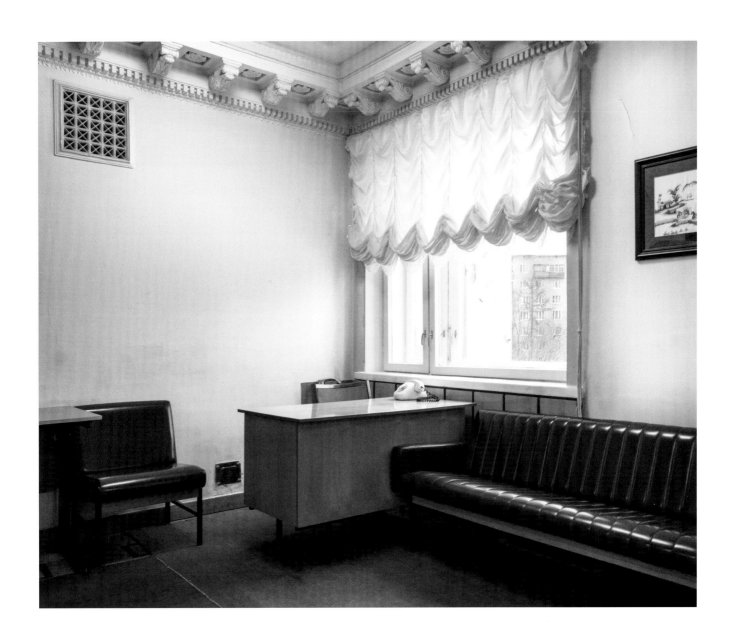

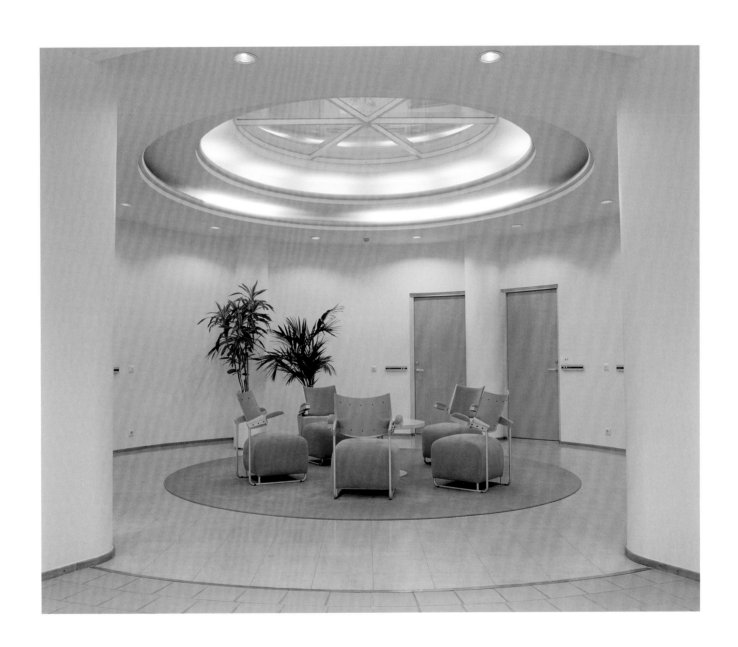

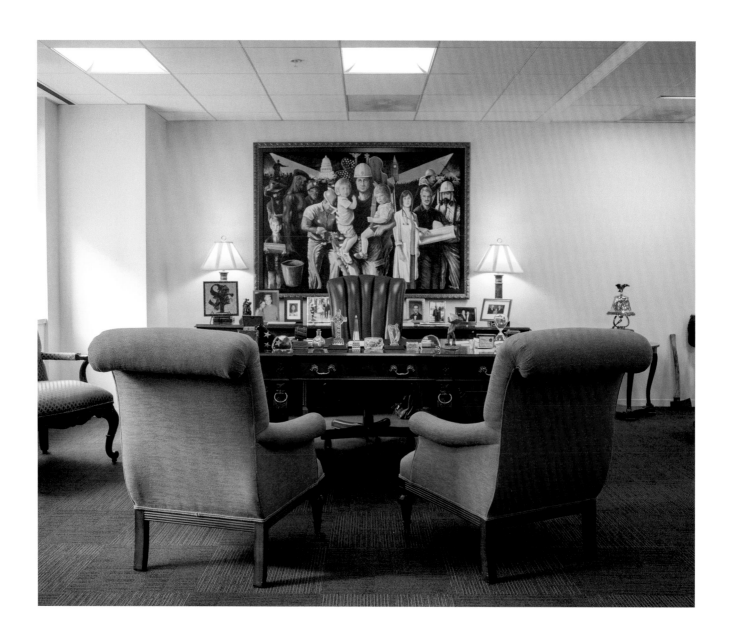

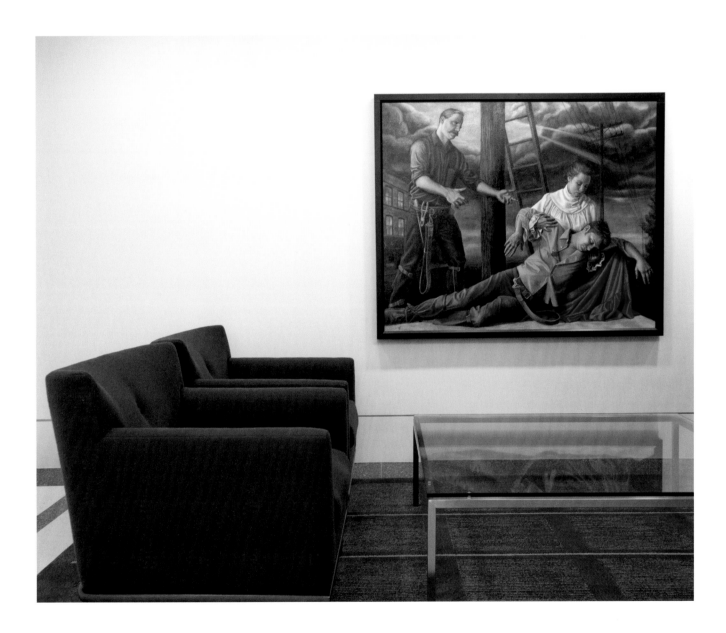

The World

1971-72
FULL MEMBER

A member's card shall stand as a statement of contributions paid, but the member shall be held responsible for its regular presentation. In no case shall arrears improperly computed affect the correct financial position of the member (see Rule 27, Clause 8). If not produced in case of dispute, the Union's books must decide.

The number of days exempt from the payment of contributions by causes stated in Rule 27, Clause 5, must be inserted on this card in the quarter they occur.

Members having money to refund must do so **from their own means,** before receiving benefit.

All members are disqualified from receiving benefit if they neglect to pay in conformity with Rule 27. Members eight weeks or more in arrears must reduce them below that amount and keep same below for four weeks before being entitled to benefit. Members whose contributions are 26 weeks in arrears are due for expulsion.

☛ The date marked thus (*) is for the Annual Election of Officers.

☛ Members are requested to use every exertion to obtain work for our unemployed, and so lighten the burden of all.

Charles Mitchell Ltd.

AMALGAMATED UNION OF ENGINEERING WORKERS
(Engineering Section)

You must notify the Secretary in writing (quoting your Contribution Card Number)—

WHEN YOU

CHANGE YOUR ADDRESS—Rule 3, Clause 7, Para. 1.
BECOME UNEMPLOYED—Rule 12, Clauses 2 and 3.
CHANGE YOUR EMPLOYMENT—Rule 12, Clause 3.
FALL SICK—Rule 30, Clause 1.
MEET WITH AN ACCIDENT—Rules 31 and 32.
ENTER H.M. FORCES.

How to Claim Benefits:—
UNEMPLOYMENT—See Rule 28.
SICK—See Rule 30.
LEGAL AID—See Rule 32.

WHEN 8 WEEKS IN ARREARS YOU ARE OUT OF BENEFIT

When in doubt ASK your Branch Secretary

Change of Address to be immediately notified to Branch Secretary

Regular Attendance and Payment of Contributions at Branch Meetings is in your own interests

BRANCH SEAL →

J Conway, General Secretary,
Amalgamated Union of Engineering Workers,
110 Peckham Road London S.E.15

Section.......... No. 12....

Shop Stewards are authorised "to examine at least once a quarter the Contribution Cards of all members"— (See Rule 13, Clause 21.)

Any member commencing work must inform his Branch Secretary and also the nearest Branch Secretary where he is at work, in writing, within 48 hours, and also give his rate of pay within three days after receiving the same or be fined 1s. (or 5p).

No Secretary is allowed, under penalty of 5s. (or 25p), to receive members' contributions out of branch meeting, except seagoing members, and such as are remitted by post, which shall be paid into the branch on the next meeting night, such sums to be then inserted on the member's card. Any member, or person acting on behalf of a member, disregarding these instructions, shall be responsible for such neglect. The Union accepts no responsibility for contributions paid in contravention of Rule 7, Clause 12.

Postal Orders sent in payment of contributions must be sent to the Branch Secretary and crossed thus //, and made payable to Amalgamated Engineering Union. Members wishing their cards returned by post should enclose a stamped addressed envelope.

Left panel (1971)

No. 12 O/P Dec............ Arrs. Dec............

1971	1	JAN. 15	29		FEB. 12	26		MAR. 12	26	
Cons., Fines, Levies.	8/	8/		40	40	40	40P			
Received by										
Levies		Fines		‡Pol. Levy 1s. (or 5p.)		Total				
Days ex. Cons.		Overpaid			Arrs.					

	APRIL 9	23		MAY 7	21		JUNE 4	18	—
Cons., Fines, Levies.	40	40	40	40			80		
Received by									
Levies		Fines		‡Pol. Levy 1s. (or 5p.)		Total			
Days ex. Cons.		Overpaid			Arrs.				

	JULY 2	16	30		AUG. 13	27		SEPT. 10	24
Cons., Fines, Levies.	40	40				50	50	50	
Received by									
Levies		Fines		‡Pol. Levy 1s. (or 5p.)		Total			
Days ex. Cons.		Overpaid			Arrs.				

	OCT. 8	22		NOV. ●5	19		DEC. 3	17	31
Cons., Fines, Levies.	40	40	40	40	40	40	40		
Received by									
Levies		Fines		‡Pol. Levy 1s. (or 5p.)		Total			
Days ex. Cons.		Overpaid			Arrs.				

‡Not chargeable to those who have contracted out.

Centre panel

AMALGAMATED UNION OF ENGINEERING WORKERS
(Engineering Section)

Name of Member A. RANDLE

Address 72. Middlewich Road

Northwich Cheshire

Section 1 Trade

Branch Sandbach 1

Secretary's Name

Address

K. THOMAS
167 SANDBACH ROAD,
LAWTON HEATH END
CHURCH LAWTON
STOKE - ON - TRENT ST7 3RA

Meeting

Branch Meetings will be held on the dates indicated herein, commencing at.........p.m. and closing at.........p.m. (Any departure from these dates and times should be notified in accordance with Rule 3, Clause 2.)

FOR SHOP STEWARD'S SIGNATURE

Jan/71	July	Jan/72	July
Feb	Aug	Feb	Aug
Mar	Sep	Mar	Sep
Apl	Oct	Apl	Oct
May	Nov	May	Nov
June	Dec	June	Dec

Right panel (1972)

No............ O/P Dec. 17½ P. Arrs. Dec............

1972	JAN. 14	28		FEB. 11	25		MAR. 10	24	—
Cons., Fines, Levies.	50	50	50	50	50	50			
Received by									
Levies		Fines		‡Pol. Levy 1s. (or 5p.)		Total			
Days ex. Cons.		Overpaid			Arrs.				

	APRIL 7	21		MAY 5	19		JUNE 2	16	30
Cons., Fines, Levies.	50	50	50	50			100	50	
Received by									
Levies		Fines		‡Pol. Levy 1s. (or 5p.)		Total			
Days ex. Cons.		Overpaid			Arrs.				

	JULY 14	28		AUG. 11	25		SEPT. 8	22	—
Cons., Fines, Levies.	50	100	50			50	50		
Received by									
Levies		Fines		‡Pol. Levy 1s. (or 5p.)		Total			
Days ex. Cons.		Overpaid			Arrs.				

	OCT. 6	20		NOV. ●3	17		DEC. 1	15	29
Cons., Fines, Levies.	50	50	50	25	50	50	50		
Received by									
Levies		Fines		‡Pol. Levy 1s. (or 5p.)		Total			
Days ex. Cons.		Overpaid			Arrs.				

‡Not chargeable to those who have contracted out. L.Y.

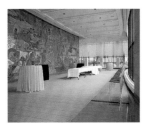

The American Federation of
Labor and Congress of Industrial
Organizations

AFL–CIO | WASHINGTON, D.C., USA

Harold Daggett, President
International Longshoremen's
Association

ILA | NEW JERSEY, USA

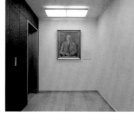

Portrait, Franz Spliedt (1877–1963)
Confederation of German
Trade Unions

DGB | HAMBURG, GERMANY

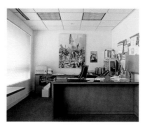

Maritime Trades Department
AFL–CIO Building

AFL–CIO | WASHINGTON, D.C., USA

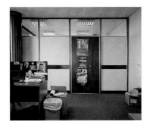

Services, Industrial,
Professional & Technical Union

SIPTU | DUBLIN, IRELAND

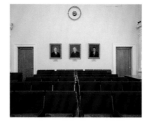

Solidarność – Independent
Self-governing Labour Union

GDANSK, POLAND

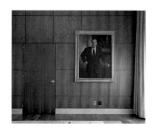

Executive Committee Meetings Hall
Federation of Independent Trade
Unions of Russia

FNPR | MOSCOW, RUSSIA

Portrait, James P. Hoffa
International Brotherhood
of the Teamsters

IBT | WASHINGTON, D.C., USA

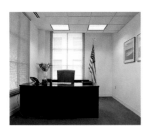

Maritime Trades Department

AFL–CIO | WASHINGTON, D.C., USA

Donald J. Marcus, President
International Organization
of Masters, Mates & Pilots

MM&P | MARYLAND, USA

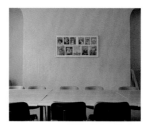

MANDATE Trade Union

DUBLIN, IRELAND

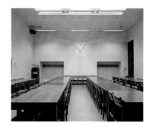

All-Poland Alliance of Trade Unions

OPZZ | WARSAW, POLAND

Sharan Burrow, General Secretary
International Trade Union
Confederation

ITUC | BRUSSELS, BELGIUM

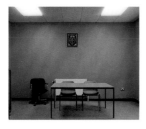

Unite the Union

UNITE | DUBLIN, IRELAND

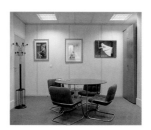

French Confederation
of Management – General
Confederation of Executives

CFE–CGC | PARIS, FRANCE

Leo Gerard, President
United Steelworkers of America

USW | PITTSBURGH – PA, USA

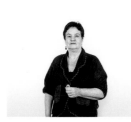

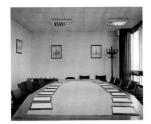

Services, Industrial,
Professional and Technical Union

SIPTU | DUBLIN, IRELAND

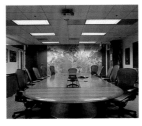

Marine Engineers' Benevolent
Association

MEBA | WASHINGTON, D.C., USA

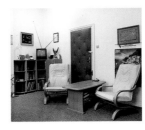

Office of the General President
Trade Union of the Electrical and
Engineering Industry of Poland

ZZPE | WARSAW, POLAND

Lobby of Secretariat Meetings Hall
Federation of Independent Trade
Unions of Russia

FNPR | MOSCOW, RUSSIA

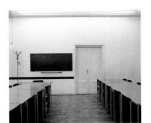

Union of Polish Teachers
Związek Nauczycielstwa Polskiego

ZNP | WARSAW, POLAND

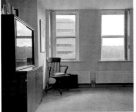

General Secretary's Office
The Association of Secondary
Teachers of Ireland

ASTI | DUBLIN, IRELAND

United Electrical, Radio and Machine
Workers of America

UE | PITTSBURGH – PA, USA

Trade Unions Forum, Poland

FZZ | WARSAW, POLAND

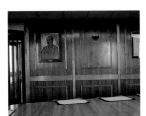

Portrait, James Connolly
Services, Industrial, Professional
and Technical Union

SIPTU | DUBLIN, IRELAND

The National Union of Rail,
Maritime and Transport Workers

RMT | LONDON, UK

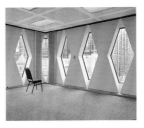

United Steelworkers of America

USW | PITTSBURGH – PA, USA

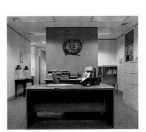

United Electrical, Radio and Machine
Workers of America

UE | PITTSBURGH – PA, USA

Larry Cohen, President
Communciations Workers
of America

CWA | WASHINGTON, D.C., USA

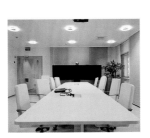

The Trade Union for the
Public and Welfare Sectors

JHL | HELSINKI, FINLAND

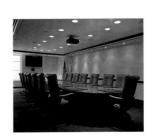

The American Federation of
Labor and Congress of Industrial
Organizations

AFL-CIO | WASHINGTON, D.C., USA

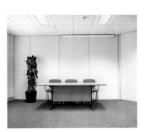

The Irish Municipal,
Public and Civil Trade Union

IMPACT | DUBLIN, IRELAND

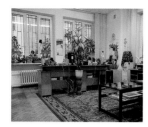

Union of Polish Teachers
Związek Nauczycielstwa Polskiego

ZNP | WARSAW, POLAND

United Transportation Union

UTU | CLEVELAND — OH, USA

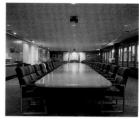

Mark Serwotka, General Secretary
Public and Commercial
Services Union

PCS | LONDON, UK

Seafarers International Union

SIU | CAMP SPRINGS — MARYLAND, USA

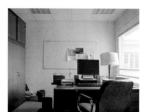

French Confederation
of Management – General
Confederation of Executives

CFE-CGC | PARIS, FRANCE

General Secretary, Len McClusky
Unite the Union

UNITE | LONDON, UK

United Electrical, Radio
and Machine Workers of America

UE | PITTSBURGH — PA, USA

Edwin D Hill, President
International Brotherhood
of Electrical Workers

IBEW | WASHINGTON, D.C., USA

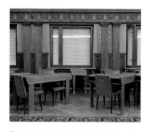

Secretariat Meetings Hall Federation
of Independent Trade Unions of
Russia

FNPR | MOSCOW RUSSIA

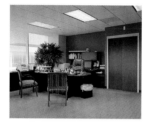

UNISON – The Public Service Union

UNISON | LONDON, UK

Marine Engineers' Benevolent
Association

MEBA | WASHINGTON, D.C., USA

Bow Crow, General Secretary
The National Union of Rail, Maritime
and Transport Workers (2002-2014)

RMT | LONDON, UK

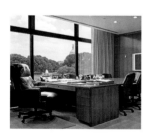

Office of the General President,
James P. Hoffa – International
Brotherhood of the Teamsters

IBT | WASHINGTON, D.C., USA

Executive Committee Meetings Hall
Federation of Independent Trade
Unions of Russia

FNPR | MOSCOW, RUSSIA

The Trade Union for the
Public and Welfare Sectors

JHL | HELSINKI, FINLAND

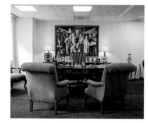

Office of Terence M. O'Sullivan,
President of the Laborers'
International Union of North America

LIUNA | WASHINGTON, D.C., USA

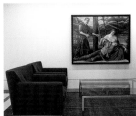

International Brotherhood
of Electrical Workers

IBEW | WASHINGTON, D.C., USA

Solidarność – Independent
Self-governing Trade Union

GDAŃSK, POLAND

Dennis Daggett, President
International, Longshoremen's
Association, Atlantic Coast District

ILA | NEW JERSEY, USA

A. Randle – Amalgamated
Engineering Union
1940–1972

A. Randle – Amalgamated
Engineering Union
1940–1972

A. Randle – Amalgamated
Engineering Union
1940–1972

Walter C. Moore – International
Association of Machinists
1949–1960

A. Randle – Amalgamated
Engineering Union
1940–1972

A. Randle – Amalgamated
Engineering Union
1940–1972

ACKNOWLEDGEMENTS

Special Thanks to:

Richard Gilligan, Ken Grant, Eoin O'Conaill, Ian Bamford, Christine Redmond, Stacey Baker, Robert Farrelly, Bill Van Loo, Shay Cody, Jack O'Connor, Terry O'Sullivan, Larry Cohen, Galen Monroe, Wayne Ranick, Agnes Schreieder, Olga Klimova, and Natalia Solarska

Bernard Harbor, Niall Shanahan, Sarah Jade Evenden, Brian Irwin, Jessica Kulak, Darren Bowler, Karl Murphy, Judy Sweeney, Lorraine Tuck, Joe Sterling, Klaus Kehrer, Barbara Karpf, Ariane Braun, Patrick Horn, Alex Kunde, Loreen Lampe, Seán Mongey, Andrew McNamee, Sharan Burrows, Candice Johnson, James P. Hoffa, Rose Conroy, Geoff Martin, Bob Crow, Len McCluskey, Alex Flynn, Leo Gerard, Alexander Vasilevski, Anders Jonsson, Anne O'Connell, Val Johnston, Dave Prentis, Harold Daggett, Dennis Dagget, Jim McNamara, Don J Marcus, Uwe Polkaehn, Mark Serwotka, Curtis Bateman, Marianna Mushadi, Tanya Kiang, Trish Lambe, Dan Scully, Pete Smyth, Daragh Shanahan, Larry Cohen, Siobhan O'Neill, Martin Parr, Paul Seawright, Donovan Wylie, Sarah Boyar, Mark Edwards, Andreea Tocca, Richard Lister, Simon Hallsworth, Lisa Wade, Evaliina Petailla, Liz Schuler, Paul Moist, Dave Heindel, David Tubman, Jim Butler, Ed Dunne, Inspirational Arts, Tony O'Brien, Rightbrain, Gallery of Photography, Dublin, Jim Fyshe, and all the team at Post Studio

The artist would like to thank all the unions that contributed to this project.

With specific thanks to:

The Irish Municipal, Public & Civil Trade Union IMPACT
Services, Industrial, Professional and Technical Union SIPTU
Marine Engineers' Benevolent Association MEBA
Laborers' International Union of North America LIUNA
Confederation of German Trade Unions DBG
Unite the Union UNITE
All-Russia Life-Support Workers' Union ALSWU
International Brotherhood of Teamsters IBT
United Steelworkers of America USW
International Longshoremen's Association ILA
The Trade Unuion for the Public and Welfare Sectors JHL
Public and Commercial Services Union PCS
Communciations Workers of America CWA

© 2015 Kehrer Verlag Heidelberg
Berlin, Noel Bowler & Authors

ARTIST:

Noel Bowler
www.noelbowler.com

INTRODUCTION:

Ken Grant

IMAGE PROCESSING:

Kehrer Design Heidelberg

PROOF READING:

Gérard A. Goodrow

DESIGN:

Post Studio
www.workbypost.com

PRODUCTION:

Kehrer Design Heidelberg
Thomas Streicher

Bibliographic information published by the
Deutsche Nationalbibliothek. The Deutsche
Nationalbibliothek lists this publication in the
Deutsche Nationalbibliografie; detailed biblio-
graphic data is available on the internet
at http://dnb.dnb.de.

PRINTED & BOUND IN GERMANY

ISBN 978-3-86828-619-9

Kehrer Heidelberg Berlin
www.kehrerverlag.com